CHRISTIAN ART
OF THE 4th TO 12th CENTURIES

CHRISTIAN ART
OF THE 4th TO 12th CENTURIES

General Editor
Francesco Abbate

Translated by
Pamela Swinglehurst

Octopus Books
London · New York · Sydney · Hong Kong

English version first published 1972 by
Octopus Books Limited
59 Grosvenor Street, London W1
Translation © 1972 Octopus Books Limited

Distributed in Australia by
Angus & Robertson (Publishers) Pty Ltd
102 Glover Street, Cremorne, Sydney

ISBN 7064 0063 1

Originally published in Italian by
Fratelli Fabbri Editore
© 1966 Fratelli Fabbri Editore, Milan

Printed in Italy by Fratelli Fabbri Editore

CONTENTS

OUTLINE OF EARLY CHRISTIAN ART

At the time of the war between Constantine and Maxentius in AD 312, the Christian communities of the Roman Empire must have aquired widespread power for Constantine to have decided to enlist their support against his rival. His wise policy of granting official recognition to those elements which had hitherto been disruptive, and the Christians' full acceptance of an Imperial authority which they had previously regarded with suspicion, is a clear indication of the changing social and ideological conditions of the times. Such changes are naturally also reflected in the field of the arts.

This close alliance between the Empire and Christianity indicates in fact a fundamental turning point not only in the history of the Church but also in the development of Christian art – a change in iconography, in basic form and spirit. Imperial patronage rose magnificently to the occasion, with the result that the bishops not only made use of the Imperial bureaucratic machine but actually became a part of it: thus the princes of the Church were now members of the ruling class responsible for directing artistic taste.

The representational art of the Empire expanded to embrace Christianity, breathing life into Christian iconography and bestowing on it the form that was to remain fundamentally unchanged for centuries to come. A new, magnificent and sumptuously rich body of art now emerged, which had little in common with the humble 'anonymous' art of Christianity's early days.

It has often been observed that the earliest Christian theologians were totally uninterested in the question of images, in the codification of a definitive repertory of Christian figures. It was probably the lay authorities, once converted to Christianity, who on their own initiative encouraged iconographic unification and codification, which was basically only a matter of adapting it to the demands of traditional royal and secular iconography.

In fact a basic uniformity is apparent in basilicas built during Constantine's reign, which apart from certain differences of detail share the same overall plan. Constantine was responsible for building many such buildings in Rome (San Pietro, San Giovanni in Laterano, San Paolo Fuori Le Mura – fourth-century churches generally erected on the outskirts on spots sanctified by Christian martyrs and their tombs), in Constantinople (Saint Sophia and Holy Apostles), in Jerusalem (Church of the Resurrection on Golgotha) and in Bethlehem (Church of the Nativity). There has been much discussion as to how and why this particular form of basilica that we find used in the Constantine era came into being – whether it derived from an adaptation of the pagan basilicas (which show the apse and the interior divided in naves), from the atrium

of private houses or from the special halls of patrician households which were used as places of worship. The halls for private worship were very similar to the public basilicas and it is highly likely that these, together with the atrium, influenced the designs of the Constantinian architects who, as Imperial employees, were certainly far more familiar with the splendid patrician dwellings than the old meeting places of the early Christians. So we can see that in the field of architecture, Christian iconography, although it made its own important contributions, was basically founded upon classical art.

The Christian basilica obeys the rules of its own symbology. The presbytery, where the altar stands, is like the heavens, to be reached by the faithful only after traversing the length of the nave with its measured progression of arches and columns. In a letter from San Nilo at the beginning of the fifth century we find his express recommendation that scenes from the Old and New Testaments should be depicted along the nave, and that the symbol of the Cross should appear in the apse. 'The Choir' thus 'evokes an intelligible heaven, the nave depicts the earth or the material universe; the images in the choir represent the culmination of God's work of salvation, and those in the nave the steps which lead man to it' (Grabar). This notion of man progressing towards the 'celestial apse' had originated in the atrium, or the quadriportico (which with its central pool was in fact very similar to the atrium in Roman houses) outside the church, where catechumens and penitents would stand. The worshipper's progress reached its triumphant climax when he approached the presbytery and

passed under the great arch at the end of the central nave, significantly called the triumphal arch. The derivation from the secular tradition of Imperial triumphal arches is obvious.

The recurrent myth of the 'purity' of the primitive churches has often depicted the first Christian basilicas as bare and unadorned, as if no reminder of transient earthly beauties should disturb the communion of the faithful and God. In reality this fancied contrast between Christian spirituality and the rich adornment and splendour of civil basilicas never existed, the more so as these churches were built at the very time when the alliance between the Emperor and Christianity inevitably laid emphasis on pomp and ceremonial, a trend that even affected that Christian art which had hitherto been overshadowed by the culture of the dominant classes. If the residence of the Emperor, Christ's vicar, was embellished as was befitting so great a personage, the more reason for the Church, the house of God, not to be poor, lowly and unadorned; particularly as the days of clandestine worship and persecutions were long since over. Mosaics, frescoes, marble – everything had to contribute to the desired effect of the church appearing as a paradise in which the soul might achieve mystical ecstasy. Ancient texts also support this concept as part of the early Christian church.

None of the Constantinian churches has come down to us intact. We learn what they must have looked like from descriptions, a few drawings and, above all, from those parts of the churches of the fourth and fifth centuries (such as Santa Maria Maggiore, Santa Sabina or the basilicas in Ravenna), in which the

1 *Barbarian art : Clasp in silver-gilt, from the island of Öland c. AD 400–50. Stockholm, Statens Sjöhistoriska Museum.*

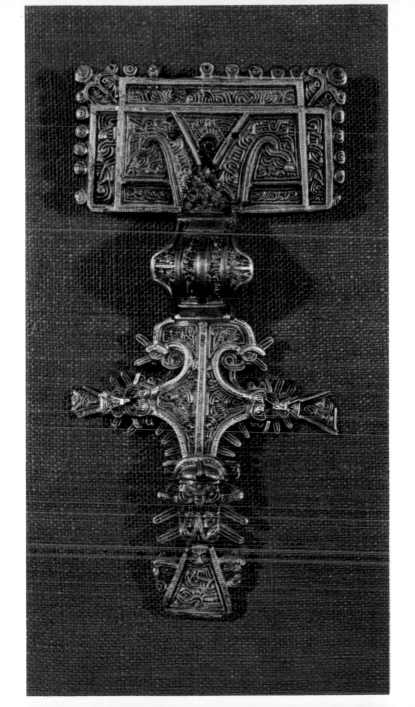

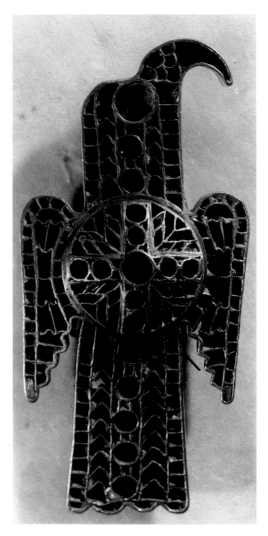

2 *Barbarian art : Gilded fibula in the shape of*
an eagle, from Cesena. V century AD.
Nuremberg, Germanisches Nationalmuseum.

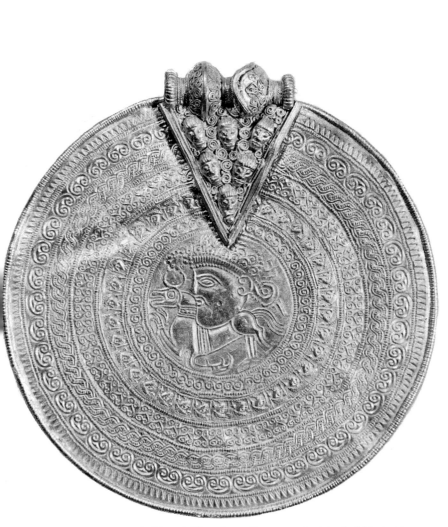

3 *Barbarian art : Gold medallion, from Gerete on the island of Gotland.*
c. AD 450–550. Stockholm, Statens Sjöhistoriska Museum.

1 Barbarian art: *Clasp in silver-gilt*, from the island of Öland. *c.* AD 400–50. Stockholm, Statens Sjöhistoriska Museum.

The Celtic taste for the ornate spread to the North, where it not only survived but became further enriched with new motifs.

2 Barbarian art: *Gilded fibula in the shape of an eagle*, from Cesena. V century AD. Nuremberg, Germanisches Nationalmuseum.

There are many examples of jewels embellished with paste and coloured stones, introduced into Italy by the Ostrogoths and the Lombards towards the fifth century AD. Although it is difficult to distinguish between the work of these two peoples, the two eagle-shaped fibulas from Cesena are held to be of Ostrogoth craftsmanship.

3 Barbarian art: *Gold medallion,* from Gerete on the island of Gotland. *c.* AD 450–550. Stockholm, Statens Sjöhistoriska Museum.

The figurative design in the centre derives from the Roman motif of the Emperor on horseback, but there is no longer any attempt at naturalism and it has been reduced to a merely decorative feature.

4

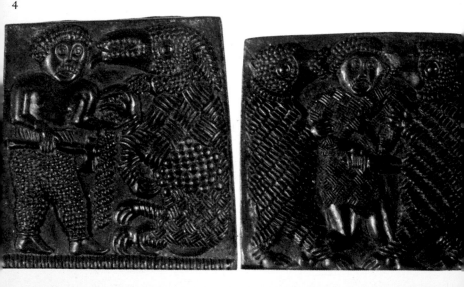

5

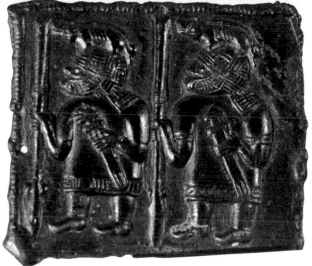

4–5 Barbarian art: *Ornamental bronze plaques*, from the island of Öland. VII century AD. Stockholm, Statens Sjöhistoriska Museum. The subjects and the treatment of the figures, the garments and the weapons are totally foreign to the repertory of the Mediterranean world: in many plaques the attitudes of the figures lead one to suppose they represent moments in ritual dances.

6 Barbarian art: *Runic stone with figure of horseman*, from Möjbro in Uppland. IV century AD. Stockholm, Statens Sjöhistoriska Museum.
The famous runic stones are gigantic monolithic slabs of rock, decorated with various kinds of figures (the horseman motif derives from Roman art) and with inscriptions in the lettering that we know as *runes*.

7 Barbarian art: *Runic stone*. Stockholm, Skansen. The runic characters, used as graphic signs but also for purposes of magic, were very widespread in Scandinavia. The greatest number of runic stones is in Sweden: the figurative markings of the oldest group date back to the fifth and sixth centuries AD.

6 *Barbarian art : Runic stone with figure of horseman,
from Möjbro in Uppland. VI century AD. Stockholm,
Statens Sjöhistoriska Museum.*

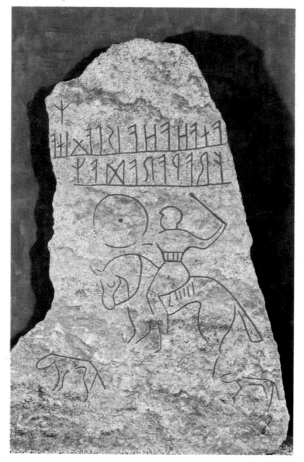

7 *Barbarian art : Runic stone. Stockholm, Skansen.*

original structure can still be clearly discerned. In Santa Maria Maggiore 'the unbroken series of huge windows', some of them now walled up, 'almost fill the nave with light', lending the interior of the church 'an airy calm . . . not unlike the atmosphere of the early civil basilicas' (Toesca). Grabar says: 'Here more than anywhere else one feels the aristocratic emphasis of Christian art when under the protection of the Emperor and the Popes, in the last centuries of the classical age.' Next to the basilicas other central-plan buildings were erected during the Constantinian period, such as the mausoleums containing the remains of Imperial personages (Santa Costanza and Sant' Elena). In Jerusalem too a rotonda called Santo Sepolcro was built over the tomb of Christ.

The Christian mausoleum is also a derivation of the pagan *heroon*, on the model of the circular tomb of Hadrian or Augustus. Santa Costanza was richly decorated with mosaics. Those which adorned the walls and the central calotte have vanished, the only remaining ones on the vault of the ambulatory and on two large open niches, one facing the other, in the perimeter wall. The latter are the only typically Christian decorations, depicting God handing the Law to Moses and to Peter. If, as is possible, these date from the fourth century, they must reflect the sacred iconography established in the Constantinian basilicas. Christ enthroned echoes representations of Imperial 'majesty'. It has already been observed how the iconography of triumphant Christianity derived from Imperial images. The halo itself was an ancient symbol of power, the dalmatic of the deacons a late Roman garment of rank, dating back to Diocletian and

the figure of the angel a clear adaptation of the classical Nike. The rest of the decoration of Santa Costanza was symbolic and ornamental, in accordance with the tradition beloved of ancient art. The surviving mosaics of the ambulatory still evoke the Hellenistic age and its impressionist technique. Similarly, the acanthus bush in one of the apses of the atrium of the Lateran baptistry is almost suggestive of the decoration of the Ara Pacis.

Catacomb paintings were still of considerable importance. One of the major fourth-century groups of paintings is the recently discovered hypogeum in the Via Latina, which contains both pagan and Christian tombs and therefore a similar mixture of paintings, indicating a remarkable spirit of mutual tolerance. In the realm of catacomb paintings the Via Latina cycle is very complete and of exceptional value. The similarity which has been observed between these frescoes and the later mosaics of Santa Maria Maggiore enables us to realize how the 'official' painting of the fourth century was not very different from that displayed on the walls of the hypogeum in the Via Latina, the burial place of a distinguished family.

Amongst the courtly arts should be mentioned also the tomb of Junius Bassus, prefect of Rome, who died in 359. This is certainly one of the masterpieces of fourth-century sculpture, an equal perhaps of the highly decorated sarcophagus of Sant' Ambrogio in Milan. It is still magnificently classical, but the more rigid set of the figures and the greater economy in the modelling, compared with that of the imposing modelling of the figures on the Roman sarcophagus, indicate the start of a new era.

8 *Roman art : Statue of consul with 'cloth'. c. AD
400 Rome, Palazzo dei Conservatori.*

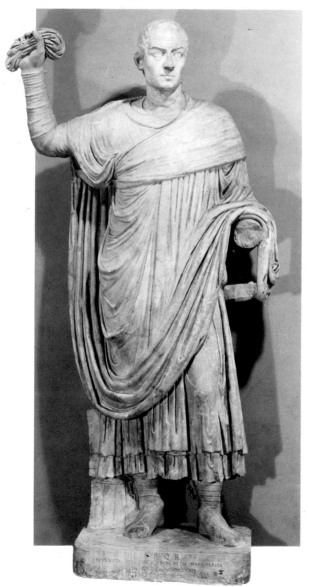

9 *Proto-Byzantine art : Statue of Valentinian II,
from Afrodisia. c. AD 390. Istanbul, Museum of
Archeology.*

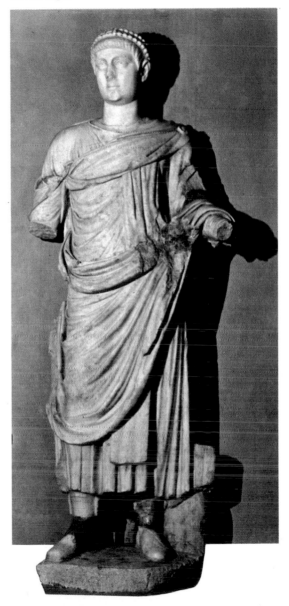

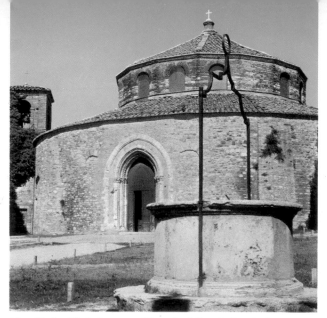

10 *Early Christian art : Church of Sant' Angelo in Perugia. End of V century.*

11 *Early Christian art : Church of Santa Costanza in Rome. First half of IV century AD.*

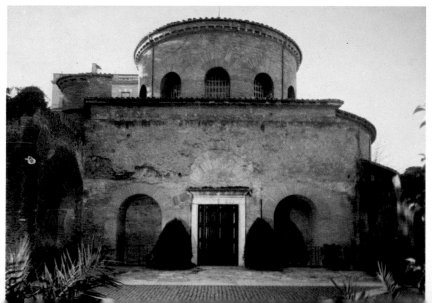

12 *Early Christian art : Detail of the ambulatory inside the Church of Santa Costanza in Rome. First half of IV century AD.*

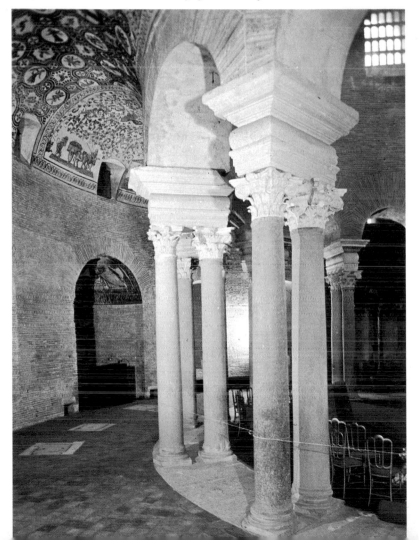

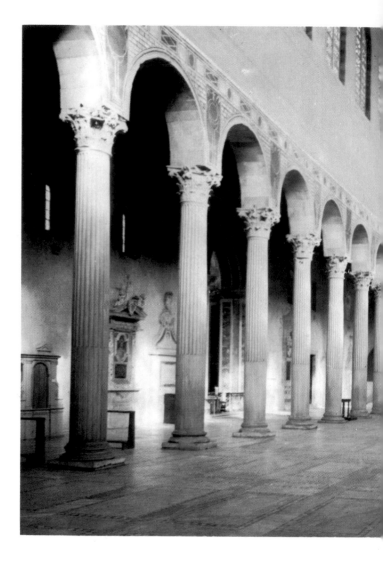

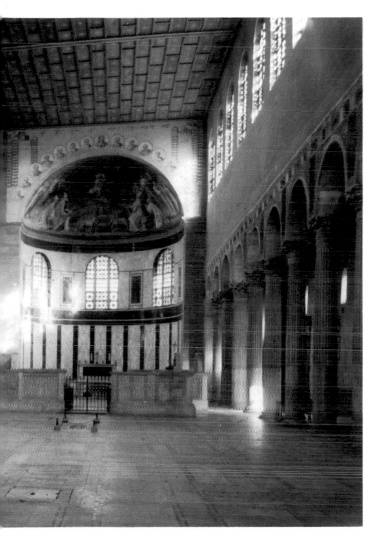

13 *Early Christian art : Interior of the Basilica of Santa Sabina in Rome. AD 422–32.*

8 Roman art: *Statue of consul with 'cloth'. c.* AD 400. Rome, Palazzo dei Conservatori. An example of the repeated use of a well-tried standard figure: the artists of the Western Empire remained conservative.

9 Proto-Byzantine art: *Statue of Valentinian II,* from Afrodisia. *c.* AD 390. Istanbul, Museum of Archeology. This is the best statue of the young prince: the lightness of the modelling accentuates the dreamy nature of the subject.

10 Early Christian art: *Church of Sant' Angelo* in Perugia.
The building was constructed at the end of the fifth century from an earlier fabric; the Gothic-type doorway dates from the fourteenth century.

11 Early Christian art: *Church of Santa Costanza* in Rome. First half of IV century AD.
In the Mausoleum of Santa Costanza, later made into a church by Alexander IV in 1256, the new Christian architecture is already evident in fully developed form; the exterior has been modified.

12 Early Christian art: *Detail of the ambulatory inside the Church of Santa Costanza* in Rome. First half of IV century AD.
Twelve pairs of Corinthian columns surround the central area covered by a hemispherical cupola on a high tympanum.

13 Early Christian art: *Interior of the Basilica of Santa Sabina* in Rome. AD 422–32. Santa Sabina shows the perfect basilical form, the central nave defined by a measured Corinthian colonnade.

14 Proto-Byzantine art: *Base of the Obelisk of Theodosius. c.* AD 390. Constantinople, Hippodrome. In AD 390 Theodosius set up in the centre of the Hippodrome in Constantinople an obelisk brought from Karnak. The base is decorated with bas-reliefs recording the inaugural ceremony.

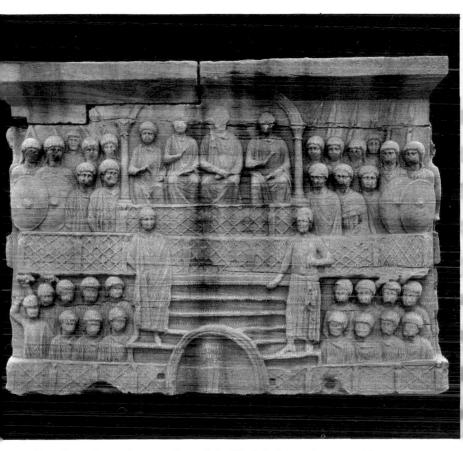

14 *Proto-Byzantine art : Base of the Obelisk of Theodosius. c. AD
390. Constantinople, Hippodrome.*

In the East, the promotion of Byzantium to the role of capital city was another of Constantine's political moves which had important repercussions on the figurative art of the late Empire. In Constantinople, where a building programme was inaugurated to convert a small provincial city into a glittering Imperial capital, a complex art form gradually developed which was as much influenced by Hellenism as by local tradition. In the Constantinian cities, as in Rome, hardly anything remains of the work fostered by the first Christian Emperor. Lost, too, are the classical statues Constantine had transported to his capital.

The artistic output of Constantinople at that time must have reflected a curious blend of traditional features and newly developing ideas and methods. Prescribed form must have been assuming an even greater importance in official art (and not only in the Orient) for the Emperor Constantius to have been represented as a stiff and hieratic 'living icon' in his triumphal entry into Rome in 357 – 'his face painted according to Persian tradition, framed by a helmet of golden hair, with a minimum of movement, staring straight ahead with fixity of expression' (Beckwith). After Constantine, Imperial art experienced another great era in the time of Theodosius the Great (379–95) under whom Christianity became the State religion. The process of progressive stylization of figures is clearly seen on the base of the obelisk of Tuthmosis III, which was removed from Karnak and re-erected on the site of the hippodrome in Constantinople. (Outstanding works of art were already imported in the days of Republican Rome from provinces rich in cultural traditions.) On the base of the obelisk are

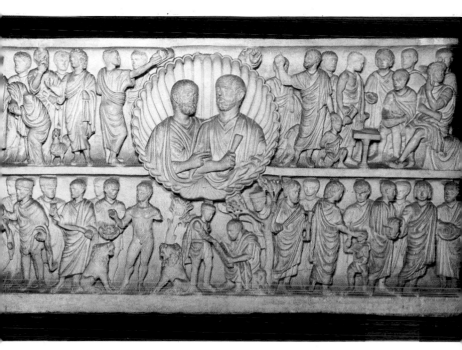

15 *Early Christian art : Sarcophagus called the 'Two Brothers'. First half of*
IV century AD. Rome, Lateran Museum.

15　Early Christian art: *Sarcophagus called the 'Two Brothers'*. First half of IV century AD. Rome, Lateran Museum. The two figures depicted inside the shell earned the sarcophagus the nickname by which it is known.

16　Early Christian art: *Detail of the Sarcophagus called the 'Two Brothers'*. First half of IV century AD. Rome, Lateran museum. Despite the character of the depicted figures, the reliefs on this sarcophagus evince a general tenor and style analogous to those of works of the pure Roman tradition.

17　Early Christian art: *Detail of the Sarcophagus of Junius Bassus*. AD 359. Vatican, Grotte di San Pietro. The inscription tells us that this is the sarcophagus of one of the leading Christian dignitaries in the Empire, formerly a consul. It is a perfect expression of the great Christian-Roman art of the mid-fourth century.

16

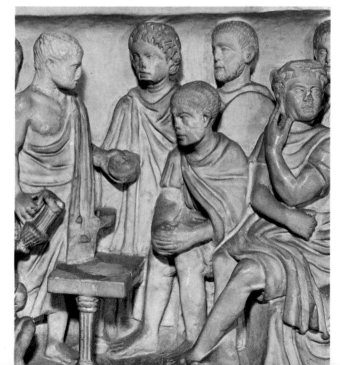

18 Early Christian art: *Detail of Sarcophagus*. Late IV
century AD. Milan, Museum of Sant' Ambrogio. The
lines of the sarcophagus and the background reliefs formed
by the city walls are architectural. In the centre of the
main side is the seated figure of Christ teaching his
disciples.

19 Early Christian art: *Ivory Capsella. c.* AD 360–70.
Brescia, Civio Museo Dell'Età Cristiana (Christian
Museum). The medallions and reliefs which decorate this
box for relics reflect the influx of late Hellenistic art.

20 Early Christian art. *Diptych of the Symmachi and
Nicomachi.* IV century AD. Paris, Cluny Museum, and
London, Victoria and Albert Museum.
This is the finest example of fourth-century pagan art,
executed to commemorate the matrimonial alliance be-
between the two powerful Roman families. The difference
in the patina of the two panels is due to their different state
of preservation.

17

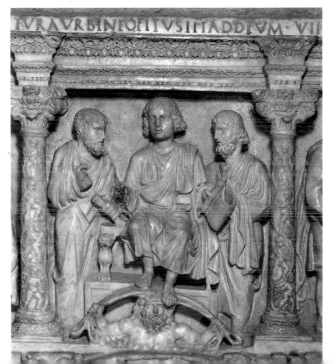

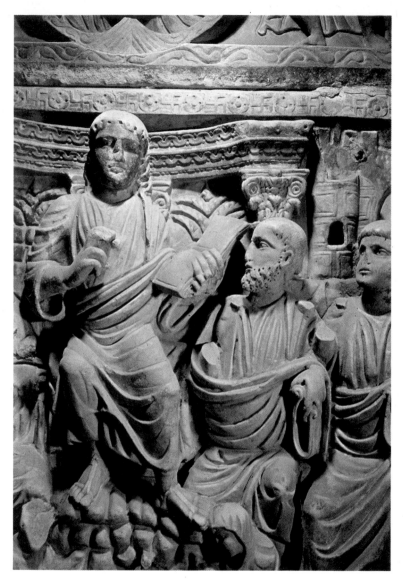

18 *Early Christian art : Detail of Sarcophagus. Late IV century AD.*
Milan, Museum of Sant' Ambrogio.

19 *Early Christian art : Ivory Capsella. c. AD 360–70. Brescia,
Civico Museo Dell'Età Cristiana (Christian Museum)*.

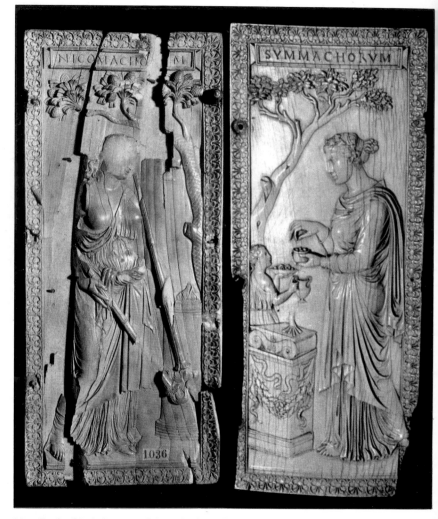

20 *Early Christian art : Diptych of the Symmachi and Nicomachi. IV century AD*
Paris, Cluny Museum, and London, Victoria and Albert Museum.

depicted Theodosius and other members of the royal
family beneath a canopy, and on the other sides the
scene of the erection of the obelisk and a chariot race.
The simple formal arrangement of figures seen front-
view is far more advanced than in the art of Constan-
tine's day. It is dominated by a rigid and impeccable
symmetry, almost as if imposed by court ceremonial.
The kneeling barbarians offering their tributes to the
Emperor, who is solemn and distant as in a theophany,
look like the formal group of Dacians in Trajan's
Column. The derivation is certainly not coincidental.
History records that Theodosius wanted to be
regarded as a new Trajan (*moribus et corpore Traiano
similis*) and had also erected a decorated spiral column
in the Tauri Forum which he had built in Constanti-
nople; the greater part of the decoration of this was
dedicated to the triumph and majesty of the Emperor.
Meantime Hellenistic tradition had not altogether
disappeared. In the head of the young Arcadius
(Istanbul Museum) for all its immobility, one can
still detect a resemblance to the heads of Alexander.
The echo of Hellenistic techniques, though certainly
more formalized and fined down, is even more evident
in the bearded head in the Musées du Cinquantenaire
in Brussels. There is classical influence too (more so at
any rate than in most contemporary official sculpture)
in the famous sarcophagus of Serigüzel. The fine floor
mosaics, which originally paved a porticoed courtyard
in the Imperial palace of Constantinople, seem almost
Alexandrian. Their date, which is disputed, is between
the fifth and sixth centuries; but whatever their date
we can agree with Beckwith who considered them as a
'link in the chain of constant returns to Hellenistic

art' always present in Constantinople. Alongside such examples there is naturally a steady development in contemporary 'schematic' art, as can be clearly seen in a series of 'consular' diptychs, especially those in the era of Anastasius, Emperor from 491–518 (diptychs of Areobindus, 506, of Clementine and Flavius Anastasius, 513 and 517 respectively, or that of Magnus, perhaps dating from 518). The static style of the Anastasian era was suddenly interrupted by the succession of Justinian (527–65), author of the first decisive classical revival.

The Justinian epoch also marked an important break in the development of the traditional Constantine basilica. In the West the tradition continued with minor modifications in the detail, while in Constantinople itself, it was completely interrupted. In the Byzantine capital there now emerged a new type of basilica with vaulted roof, given the seal of approval by the magnificent rebuilding of Santa Sophia, which had been burnt down in 532. We know that Justinian spared no expense to make Santa Sophia the most splendid church in the whole empire, as if seeking to recreate the splendour of Nebuchadnezzer or the refined magnificence of Tuthmosis III or Amenhotep III. The church erected by Anthemius of Tralles and Isidorus of Miletus, is almost square and is dominated by a big central dome (flanked by two half domes), assuredly the most important architectural and artistic feature of the entire building. This huge central dome was a favourite theme of Justinian architecture, and was used in the Holy Apostles – another reconstructed Constantinian church – and the SS Sergio e Bacco, as well as Santa Sophia. We

21 *Early Christian art : The pious women at the Sepulchre, panel of an ivory diptych. c. AD 400. Munich, Bayerisches Nationalmuseum.*

22 *Early Christian art : Diptych of the consul Basilius, front panel. AD 480. Florence National Museum (Bargello).*

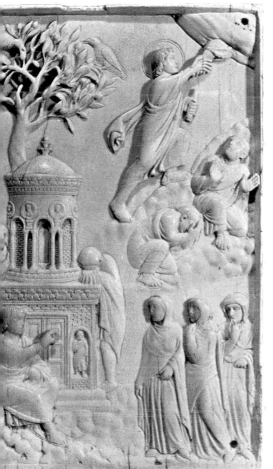

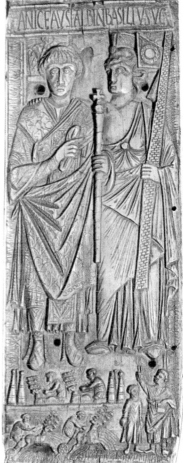

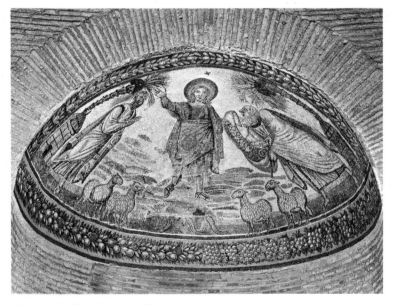

23 *Early Christian art: Christ giving the Law to Peter and Paul, mosaic in the apse of the Church of Santa Costanza in Rome. First half of IV century AD.*

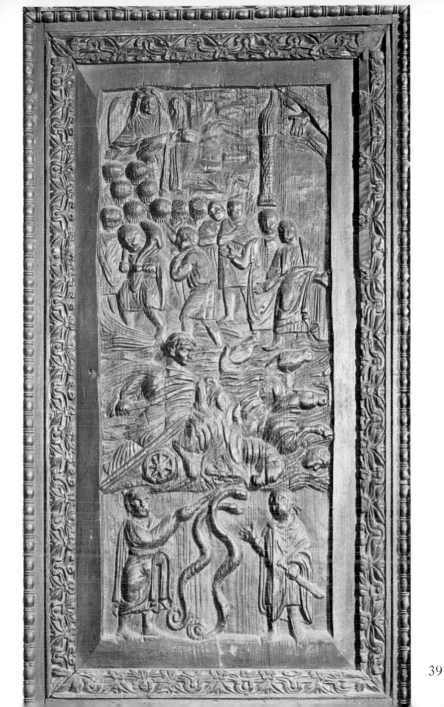

39

21 Early Christian art: *The pious women at the Sepulchre*, panel of an ivory diptych. *c.* AD 400. Munich, Bayerisches Nationalmuseum.
The episode of the pious women inspired the decoration on this panel, probably made in Northern Italy.

22 Early Christian art: *Diptych of the consul Basilius*, front panel. AD 480. Florence, National Museum (Bargello). This series of consular diptychs provide us with precious evidence of the evolution of early Christian art.

23 Early Christian art: *Christ giving the Law to Peter and Paul*, mosaic in the apse of the Church of Santa Costanza in Rome. First half of IV century AD.
These early basilican mosaics still belong, in their impressionistic style, to the best Roman artistic tradition, worthily bringing the cycle to its close.

24 Early Christian art: *The Crossing of the Red Sea*, detail of the wooden door of the Basilica of Santa Sabina in Rome. *c.* AD 430. In the reliefs on the wooden door of Santa Sabina many critics incline to discern the hand of two different artists.

25 Early Christian art: *Naturalistic composition*, detail of the mosaic in the vault of the Church of Santa Costanza in Rome. First half of IV century AD. One of the oldest groups of mosaics that has come down to us is the decoration of the vault of Santa Costanza (greatly restored).

26 Early Christian art: *Christ triumphant*, mosaic in the apse of the basilica of SS Cosma e Damiano in Rome. VI century AD. In this great mosaic all background detail has disappeared and the iconography is taken from imperial art.

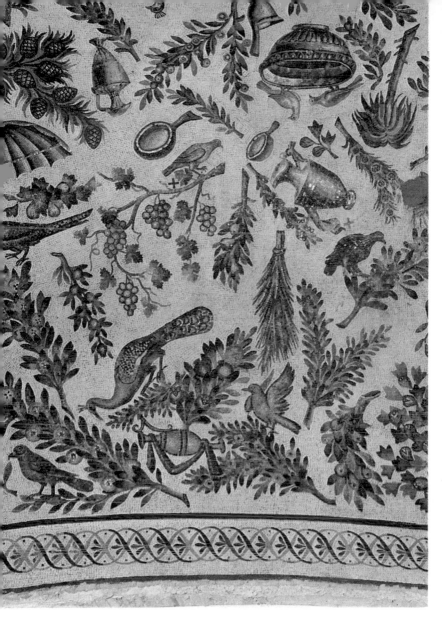

25 *Early Christian art : Naturalistic composition, detail of the mosaic in the vault of the Church of Santa Costanza in Rome. First half of IV century AD.*

41

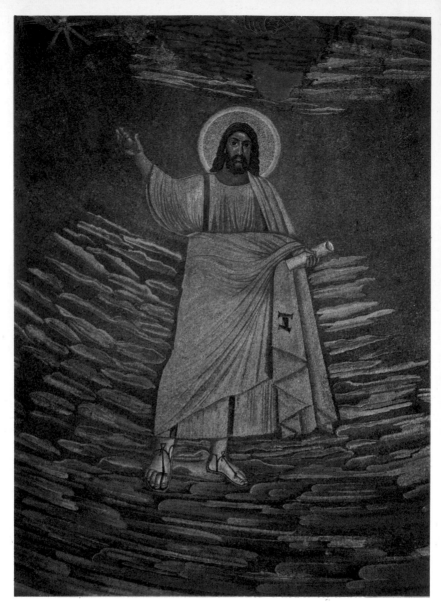

26 *Early Christian art: Christ triumphant, mosaic in the apse of the basilica of SS Cosma e Damiano in Rome. VI century AD.*

can unhesitatingly agree with Grabar's conclusion that 'the baldacchino dome is the constant element, whilst the actual ground plan of the church over the centre of which the dome was to be placed is variable'. It was also Grabar who noted that 'there can never be sufficient attention paid to the artistry with which the architects of Santa Sophia made use of the sunlight'. Perforated around the base with an almost unbroken circle of windows, the big dome seems almost suspended, as if the architects had sought to convey the unreal quality, the blinding, mysterious, ineffable splendour of a vision of paradise.

The Justinian innovations made little impression outside Constantinople. In other regions, both in East and West, the Constantinian form of basilica continued to prevail. Only San Vitale in Ravenna shows a marked Byzantine influence in its design.

Witnesses to the Justinian revival are the ivory diptychs of the Muse and the Poet in Monza, and the silver plates, among the most valuable works of their period in the realm of applied arts. In the latter field there is a steady development from the formal official art of Theodosius (whose truly beautiful *Missorium*, now in Madrid, echoes artistic tradition in the base of the obelisk, but with concessions to a greater fluidity of form and freer imagination) through the reign of Anastasius, down to Justinian's classical restoration, clearly shown in the plate with the pastoral scene in the Leningrad Hermitage. This plate bears the mark of Justinian stamped into the silver, and such a mark is of course fundamental to fixing a date in a period when dating is highly controversial.

This 'Hellenistic' tradition persists in silverware of

the time of Heraclius (610–41), which was clearly inspired by the Justinian models. Eloquent examples are the plate depicting a silenus and a maenad dancing (in the Hermitage), the small pails with classical figures (Hercules, nereids, scenes from mythology) and lastly the famous plates depicting the story of David. Whilst Justinian had restored the political unity of the Empire – and it is important to note that from the ideological viewpoint the barbarians were considered as being outside the Empire, only half a century after Emperor Zeno had invested Theodoric with power over Italy in 488 – from the time of Theodosius onwards the cultural unity of the Empire was fast disappearing. This disruptive process was in large measure due to the rise of new capitals such as Milan and Ravenna (the capital of Honorius), and the continued importance and cultural influence of such ancient Hellenistic cities as Antioch and Alexandria. The artistic milieu of Milan must have been of great importance even in the fourth century. The tendency today is to consider it as not only earlier than that of Ravenna but even directly responsible for the rise of art in the latter city. 'Capital of the Empire under Theodosius, Milan more than Rome turned towards the outlying provinces . . . And on the basis of this Hellenized Latinity, more sensitive to colour and pictorial art, there developed first in Milan and later in Ravenna (not the other way round, as was believed for a long time) the new Italian style' (Chastel).

The original shape of San Lorenzo, difficult to reconstruct, leaves important problems of derivation – such as whether the vaulted roof was already known in the West before the example of Santa Sophia –

unresolved. But it must nevertheless have influenced the architects of San Vitale in Ravenna in more than one respect. Apart from San Lorenzo, other notable early Christian buildings were constructed from the series of small basilicas which stood on the site of the fifth-century Sant Ambrogio (the only surviving building, Sant Victor in the Golden Sky, is now in fact part of the Kaya church) and from the churches founded by Saint Ambrose (San Nazaro Maggiore, San Simpliciano), which made fourth-century Milan one of the strongholds of Christian orthodoxy in its struggle against Aryanism.

Ravenna is among the few major centres of early Christianity which has preserved, along with its mosaics, a number of the many buildings which once embellished the city. Architecturally, the usual form – on a central plan like the basilicas–continued, with slight variations. One such variation was the introduction, between the capital and the import of the arch, of the pulvinar shaped like an inverted pyramid, a feature which confers greater elegance and grace to the series of arches.

Other modifications were the cylindrical campanile and the polygonal exterior of the apse which had already made its appearance in the fourth century, in the basilica erected by Bishop Orso (now destroyed). The most famous of the mausoleums in Ravenna is certainly that of Galla Placidia – although it is far from certain that the sister of Honorius was actually buried in it. It is not round like the Roman mausoleums, but in the form of a Latin cross, with one of the arms slightly longer than the other. The interior is completely covered with mosaics, like some huge and

27 *Early Christian art: SS Materno e Naborre, Mosaic in the Chapel of Saint Victor in the Golden Sky, San Vittore in Ciel d'Oro, part of Sant' Ambrogio in Milan. Beginning of V century AD.*

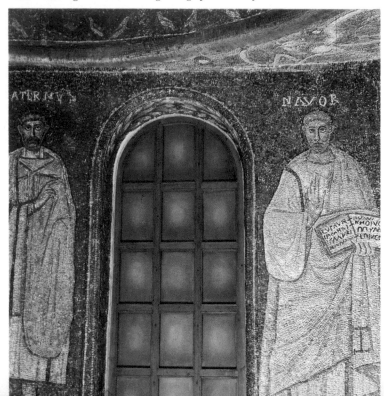

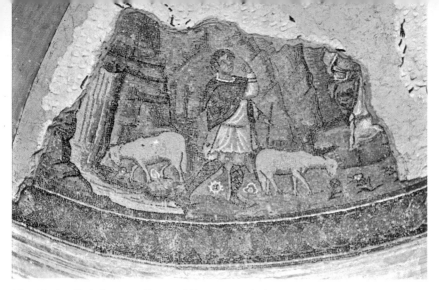

28 *Early Christian art: Pastoral Scene, mosaic in the chapel of Sant' Aquilino in the Church of San Lorenzo in Milan, V century AD.*

29 *Art of Ravenna: Christ in Judgment separating the sheep from the goats, mosaic in the nave of the Church of Sant' Apollinare Nuovo in Ravenna. c. AD 500–26.*

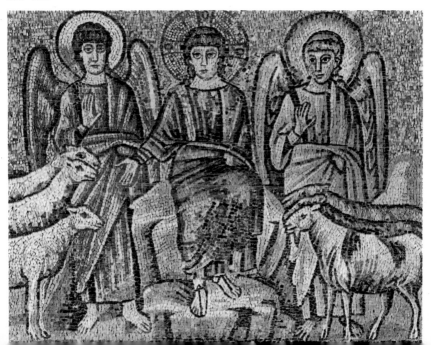

27 Early Christian art: *SS Materno e Naborre*, Mosaic in the Chapel of Saint Victor in the Golden Sky, San Vittore in Ciel d'oro, part of Sant' Ambrogio in Milan. Beginning of V century AD.
The mosaics in Milan represent the western version of ancient Christian art; the craftsmanship is rather un-sophisticated but very expressive.

28 Early Christian art: *Pastoral Scene*, mosaic in the chapel of Sant' Aquilino in the Church of Sant Lorenzo in Milan, V century AD.
This fragment of mosaic is part of a complex of scenes in the apse on the left, depicting several shepherds as the chariot of Christ crosses the sky.

29 Art of Ravenna: *Christ in Judgment separating the sheep from the goats*, mosaic in the nave of the Church of Sant' Apollinare Nuovo in Ravenna. *c.* AD 500–26. The scene is part of a series of mosaics that decorate the nave in three zones one above the other. The artists were perhaps familiar with the arts of Constantinople from icons or illuminated manuscripts.

30 Art of Ravenna: *The Baptism of Christ and the Twelve Apostles*, mosaic in the Arian Baptistry in Ravenna. V century AD. The Arian Baptistry was built in Ravenna during the reign of Theodoric. The central medallion has been much restored.

31 Art of Ravenna: *Stag at the Fountain of Life*, detail of the mosaic in a lunette in the Mausoleum of Galla Placidia in Ravenna. V century AD. The Ravenna mosaics are of great artistic value although they are greatly indebted to classical tradition and evince an uncertain technique.

32 Art of Ravenna: *The Good Shepherd*, mosaic in the Mausoleum of Galla Placidia in Ravenna. V century AD. The Galla Placidia mosaics represent one of the most complete and interesting achievements of the school of Ravenna.

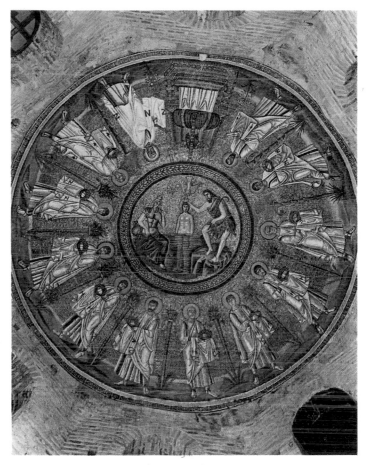

30 *Art of Ravenna : The Baptism of Christ and the Twelve Apostles,
mosaic in the Arian Baptistry in Ravenna. V century AD.*

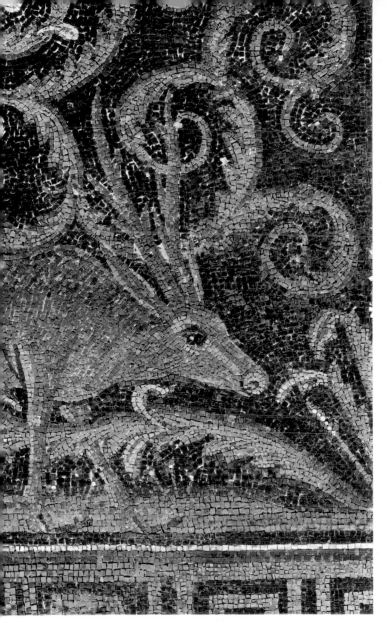

31 *Art of Ravenna : Stag at the Fountain of Life, detail of the mosaic in a lunette in the Mausoleum of Galla Placidia in Ravenna. V century AD.*

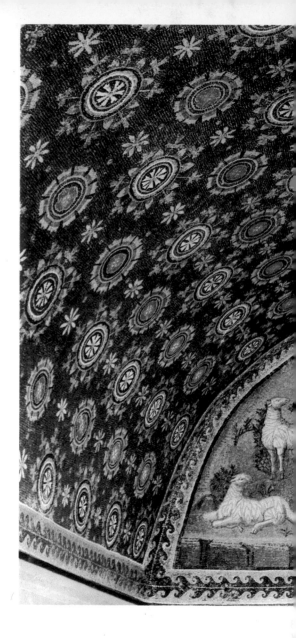

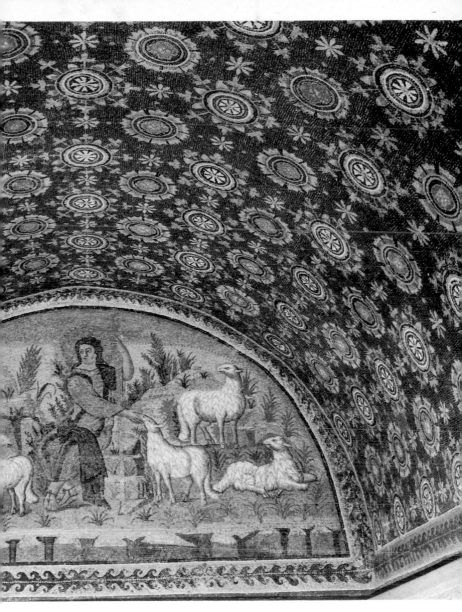

82 *Art of Ravenna : The Good Shepherd, mosaic in the Mausoleum of Galla Placidia in Ravenna. V century AD.*

precious oriental carpet. A strong oriental influence (from the Copts and Chaldeans) has often been remarked in the mosaics of the mausoleum, alongside the usual Hellenistic features, such as in the lunette of the Good Shepherd. But the overall effect is certainly new and original, the dominant theme provided by the big stylized roses against a deep blue background, evoking a night sky full of stars, an astral meditation upon death.

The central plan building of Theodoric's mausoleum is very different, but also shows a tendency for unusual forms and original effects, particularly in the large serrated frieze of the calotte, set on the cylindrical tambour like some barbarian helmet. Whilst it has often been remarked that the mausoleum cannot be the expression of a Gothic style, which certainly did not exist, there is certainly some basis for believing that its particular form was dictated by the ideas and taste and wishes of Theodoric himself, who, educated at the Imperial court of Byzantium, can hardly have been uninformed in artistic matters.

The Orthodox Baptistry, reconstructed by Bishop Neone, belongs to the second half of the fifth century. The rich decoration of the interior dates from the same period, the walls and vault being entirely covered, as in the Galla Placidia mausoleum, with marble, stucco-work and mosaics. In the solemn file of the twelve Apostles and the Baptism of Christ in the cupola, the Graeco-Roman tradition is very much more pronounced than in the Galla Placidia. The figures are modelled with 'well defined reliefs' and the colours 'handled with an uncommon mastery of impressionism, a mingling of different shades lending

the faces a rare lifelike quality, an impression of real emotions' (Toesca), so that we can understand how Galassi came to be reminded of the Egyptian Fayyum portraits.

Theodoric also gave a great impetus to building and architecture in Ravenna. Sant' Apollinare Nuovo is notable among the basilicas built during his reign, and although it no longer possesses the golden ceiling which earned the church its name of Saint Martin in the Golden Sky, as it was then and subsequently called, its mosaics still bear witness to the brilliance and glitter that filled an early Christian interior. Around the upper part of the nave is a series of panels depicting scenes from the life of Christ, treated with the impressionistic economy of narrative favoured by the art of antiquity. In the middle stand the dominating figures of saints and prophets, huge and statuesque. On the lower fascia the mosaics of Theodoric's day were replaced in the Justinian period, at the order of Archbishop Agnellus (556–69), when the basilica passed from the Arian cult to the Catholic. The procession of Theodoric and his court, depicted as leading from the royal palace to the majesty of Christ and Mary portrayed in the apse, was replaced by the measured file of saints and sumptuously attired, highly ornate virgins.

Of a later date are the basilicas of Sant' Apollinare in Classe (consecrated in 549 by Archbishop Maximian) and San Vitale, an octagonal or circular-plan church founded by Bishop Ecclesius (521–34) and finished under Maximian (547). In San Vitale the Byzantine influence is predominant: in 540 Ravenna had for the first time been liberated from the Ostrogoths by

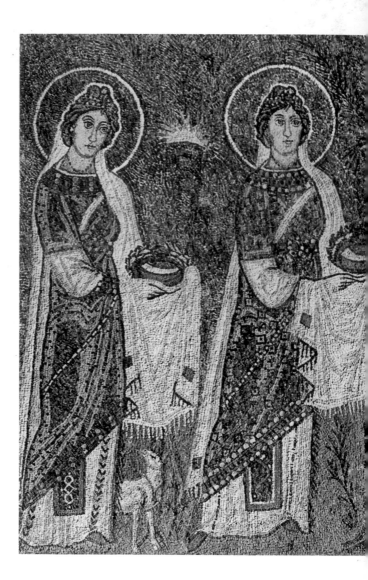

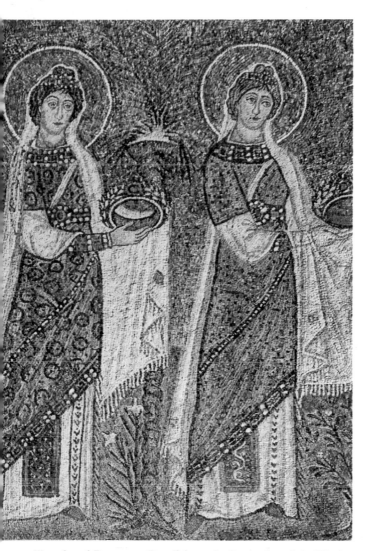

33 *Art of Ravenna : Detail from the Procession of the Virgins,
mosaic in the Church of Sant' Appolinare Nuovo in Ravenna.
VI century AD.*

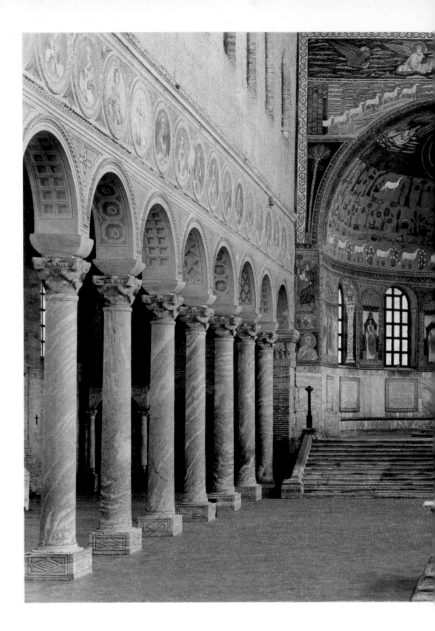

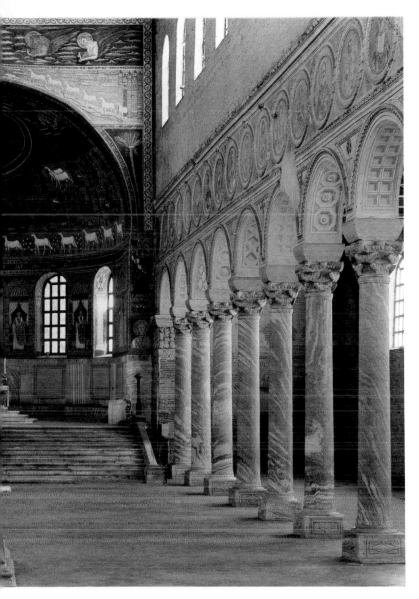

34 *Art of Ravenna : Interior of the Basilica of Sant' Apollinare in Classe in Ravenna. AD 535–49.*

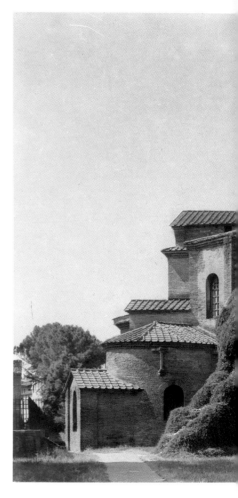

35 *Art of Ravenna :*
Apse of the Basilica
of San Vitale in
Ravenna. First half
of VI century AD.

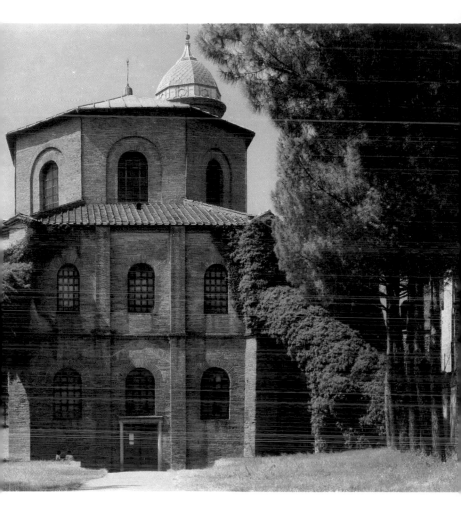

61

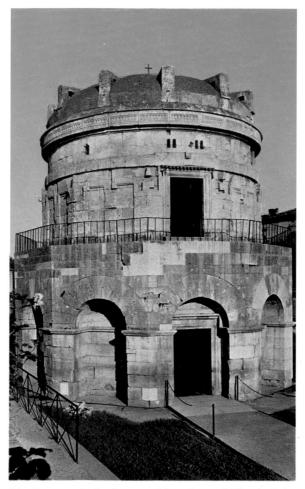

36 *Romano-barbarian art : Mausoleum of Theodoric in Ravenna. First half of VI century AD.*

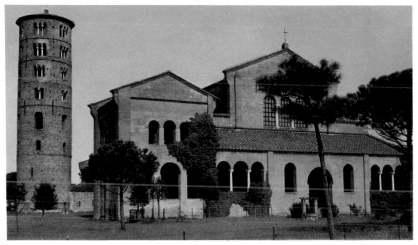

37 *Art of Ravenna : Basilica of Sant' Apollinare in Classe in Ravenna. AD.*
535–49.

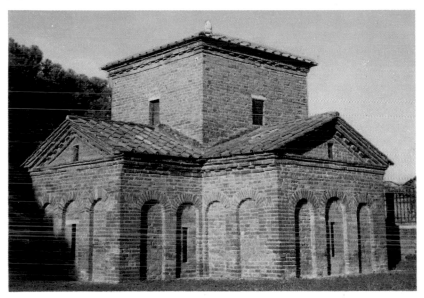

38 *Art of Ravenna : Mausoleum of Galla Placidia in Ravenna : First half of V*
century AD.

33 Art of Ravenna: *Detail from the Procession of the Virgins*, mosaic in the Church of Sant' Apollinare Nuovo in Ravenna. VI century AD. The 'Theory' of the Virgins is one of the purest examples of mosaic art in Ravenna. Proceeding from the city of Classe the maidens are advancing to pay homage to Christ and the Virgin.

34 Art of Ravenna: *Interior of the Basilica of Sant' Apollinare in Classe* in Ravenna. AD 535–49.
The interior of Sant' Apollinare is bathed in light which streams in along the columns and culminates in the shell of the apse.

35 Art of Ravenna: *Apse of the Basilica of San Vitale in Ravenna*. First half of VI century AD. An outstanding feature of the Basilica of San Vitale is the geometrical unity of its exterior with its regular sequence of piers and big windows.

36 Romano-barbarian art: *Mausoleum of Theodoric* in Ravenna. First half of VI century AD. Calls to mind the structure of Roman mausoleums and reflects the influx of Syriac art in the monolithic cupola-shaped roof.

37 Art of Ravenna: *Basilica of Sant' Apollinare in Classe in Ravenna*. AD 535–49.
Despite the restoration it has undergone, the building still retains much of its original appearance. The campanile, on the other hand, is of a much later date.

38 Art of Ravenna: *Mausoleum of Galla Placidia* in Ravenna. First half of V century AD. The exterior of the building, so simple as to seem almost bare, conveys no idea of the harmony of the interior, with its central cupola and the typical barrel-vaults in the wings.

39 Art of Ravenna: *Capital in the Church of San Vitale* in Ravenna. First half of VI century AD. Some of the capitals in San Vitale are inspired by the magnificent 'fretwork' on the capitals in Santa Sophia in Constantinople.

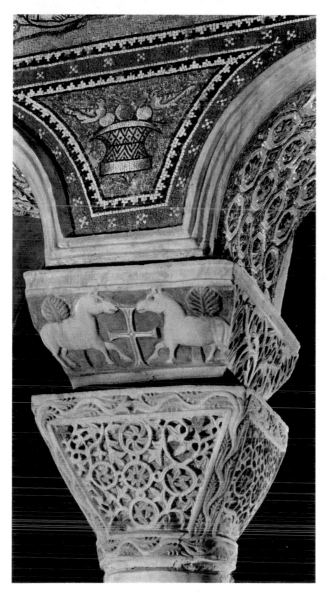

39 *Art of Ravenna : Capital in the Church of San Vitale
in Ravenna. First half of VI century AD.*

Belisarius and in 553 permanently restored to Justinian. The mosaics themselves are of mixed style. The Biblical mosaics in the presbytery still echo the Hellenistic tradition, but those in the apse, representing Christ enthroned, between San Vitale and Bishop Ecclesius offering up the model of the church, and especially the two consecration scenes in which Justinian, Theodora, high-ranking dignitaries of the Empire and Archbishop Maximian offer gifts for the church, speak a language hitherto unknown in the West. The mosaic theophany in the apse has something of the stately but rigid oriental iconography, the rich and magnificent robe of San Vitale being comparable to the sumptuous attire of the Imperial dignitaries in the two Justinian panels. The only Hellenistic element in the two processions is in the lively modelling of the figures and the humanity of the expressions. The Emperor who in the East restored the classical tradition is represented in San Vitale in a style far removed from the style of Western painting. It is highly probable that the Imperial panels in San Vitale were the work of craftsmen sent out from Constantinople; their style differs greatly (inferior or superior, according to your point of view) from contemporary Western art. Certainly it was more strongly rooted in Hellenistic-Roman tradition. But this in no way detracts from the quality of the Justinian mosaics in San Vitale, which can rightly be numbered among the greatest of Byzantine masterpieces.

It was partly as a result of its political importance and the resultant formation of a Byzantine bureaucracy to govern the city, that Ravenna from that time on became the principal Italian market for imported eastern

art. The beautifully sculpted ivory throne of Arch-
bishop Maximian, one of the largest objects of its kind
to have survived, is markedly oriental in character,
more evocative of Egypt and Syria than of Con-
stantinople.

In Ravenna, as in Rome, sarcophagi were manufac-
tured in quantity. So busy was the trade that Theodoric
was forced to issue decrees limiting production,
granting a monopoly to Daniele, the court sculptor.
The Ravenna sarcophagi display particular features
which distinguish them from those made in Rome,
The lid is not flat but semi-cylindrical or roof-shaped,
as if harking back to the concept of the tomb as the
dwelling place of the dead, familiar to the pagan mind
but alien to Christian belief. Scenes of theophany or
allegory occur frequently, but although the Ravenna
sarcophagi are decorated on every side they never
present a complete sequence as do the Roman
examples. The chronology of these sculpted sarco-
phagi is uncertain, but the one in the church of San
Francesco, with the *traditio legis*, which in certain
features echoes the noble classicism of the sarcophagus
of Junius Bassus, and the sarcophagus known as
Pietro Peccatore's in Santa Maria in Porto Fuori, are
certainly among the oldest. The later trend was
towards simplicity of form, in keeping with the
increasingly allegorical character of the subjects.

One of the most famous and unusual of the Ravenna
sarcophagi, perhaps dating from the fifth century, is
the one known as the Sarcophagus of Isaac, in San
Vitale. In the scene of the Adoration of the Magi, the
figure in the middle is turning to look at his companion
following him – a movement that breaks the monotony.

In Rome the most comprehensive collection of fourth and fifth century figurative art is to be found in the mosaics of Santa Maria Maggiore. The cycle does not appear unified, and should probably be attributed to different periods, although there is some controversy on this point. The oldest mosaics are those in the nave depicting stories from the Old Testament, which unfold in a series of dramatic scenes enlivened by the use of vivid colours and brilliant rich lines.

There is less vivacity of narrative in the mosaics of the triumphal arch, which depict scenes from the New Testament in a more solemn and stylized fashion. The mosaic in the apse of Santa Pudenziana dates from the end of the fourth century. The changeover from Imperial to Christian iconography is by now clearly evident in the imposing figure of Christ in his golden raiment and the throne encrusted with precious stones. The Christ of Santa Pudenziana is in some ways the precursor of the magnificent Christ in the apse of SS Cosma e Damiano, a dominating figure above a perspective of clouds, hand raised in the traditional gesture of a Roman orator. The tremendous vigour of this Christ would certainly have appealed to Masaccio had he seen it on one of his journeys to Rome. There is a great difference between this realistic, almost earthly treatment of the deity and the more or less contemporary one in San Vitale, which looks like some 'royal ceremony . . . Here, apart from a few typical details such as the sumptuous garment that confers the required note of pomp to the figure of San Theodoro, we see in the apse of SS Cosma e Damiano the most Roman mosaic of the period' (Grabar).

It has been remarked that the mosaics of Santa Maria

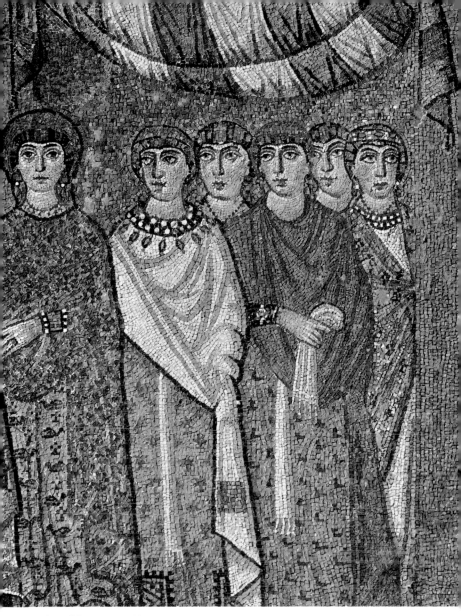

40 *Art of Ravenna: Theodora's ladies-in-waiting, mosaic in the Church of San Vitale in Ravenna. First half of VI century AD.*

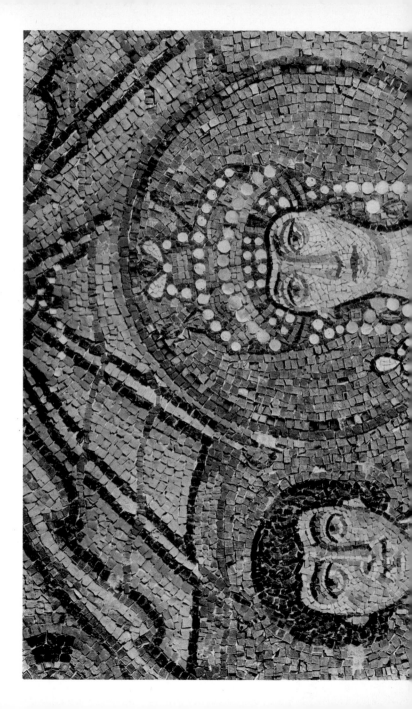

41　Art of Ravenna: The Empress Theodora, mosaic in the Church of San Vitale in Ravenna. First half of VI century AD.

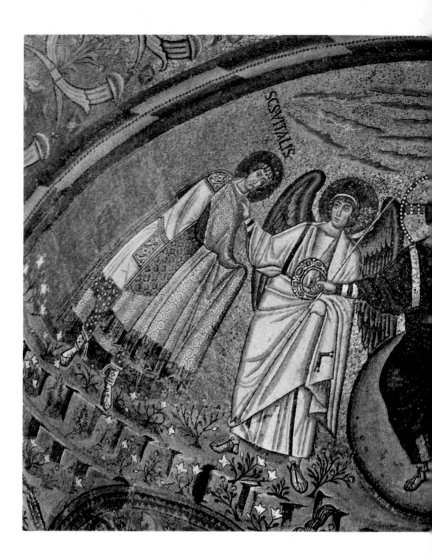

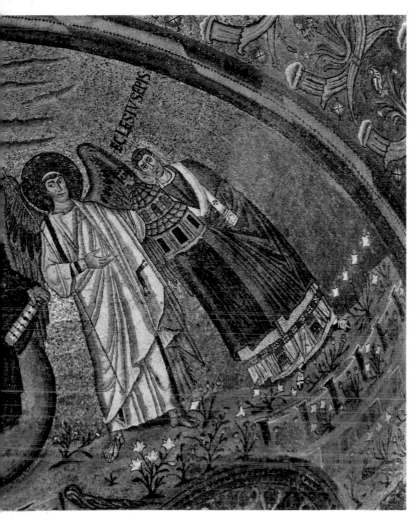

42 *Art of Ravenna : Christ between angels and saints, mosaic in the apse of the Church of San Vitale in Ravenna. First half of VI century AD.*

40 Art of Ravenna: *Theodora's ladies-in-waiting*, mosaic in the Church of San Vitale in Ravenna. First half of VI century AD.
The figures of Theodora's ladies, lined up and seen full-face, convey no impression of modelling and dimension, and come alive only through the vibrant colour of the tessera of the mosaic.

41 Art of Ravenna: *The Empress Theodora*, mosaic in the Church of San Vitale in Ravenna. First half of VI century AD. The sides of the presbytery of the Church of San Vitale glitter with the two panels depicting the Emperor Justinian and Empress Theodora bringing offerings to the temple.

42 Art of Ravenna: *Christ between angels and saints*, mosaic in the apse of the Church of San Vitale in Ravenna. First half of VI century AD.
Standing out against the golden background in the apse of San Vitale is the figure of Christ, holding in his left hand the crown of martyrdom for San Vitale. On his left are an angel and Saint Ecclesius, who is holding the model of the Church.

43 *Art of Ravenna : Detail of the Throne of Archbishop Maximian. AD 546–56 Ravenna, Museo Arcivescovile.*

43 Art of Ravenna: *Detail of the Throne of Archbishop Maximian.* AD 546–56. Ravenna, Museo Arcivescovile.
The magnificent decorative framed panels of the throne call to mind certain Coptic or Syrian compositions, whilst the style and design of the scenes and the figures have features in common with certain Graeco-Oriental works in ivory of the sixth century.

44 Byzantine art: *Sarcophagus of Serigüzel.* IV century AD. Istanbul, Museum of Archeology.
The pureness of the composition and the symmetrical balance of the two angels introduce us to the spiritual climate of true Byzantine art.

45 Byzantine art: *Marble bust of Evangelist.* V century AD. Istanbul, Museum of Archeology. This bust, originally inserted in a wall medallion, is one of a group of four similar reliefs that almost certainly represent the four Evangelists.

44 *Byzantine art : Sarcophagus of Serigüzel. IV century AD. Istanbul, Museum of Archeology.*

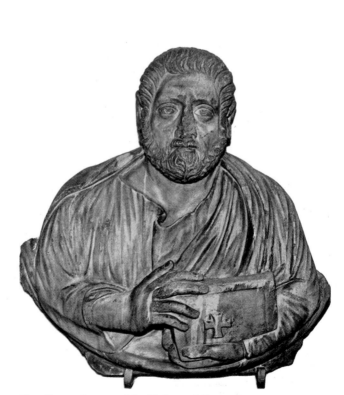

45 *Byzantine art : Marble bust of Evangelist. V century AD.*
Istanbul, Museum of Archeology.

Maggiore, particularly those in the nave, probably derive (especially in their iconography) from illuminated manuscripts stylistically akin to the Vergilius Vaticanus and the Vergilius Romanus, both kept in the Vatican library. Of a later date than the mosaic decoration of Santa Maria Maggiore are certain manuscripts which date from the sixth century, such as the Ambrosiana Iliad, the Vienna Genesis, the Paris Codex sinopensis and the Rossano Gospel. All of these are notable for the brilliance of their colouring and an intensity of narrative—at times, as in the Ambrosiana Iliad, highly dramatic – that cannot fail to remind one of the mosaics in the Liberiana basilica.

In the realm of sculpture, apart from the sarcophagi the most notable example of fifth-century work in Rome is to be found in the wooden doors of Santa Sabina, which are carved with scenes from the Old and New Testaments, framed in vine branches. The style of the carvings is not unified: alongside the strictly classical ones are others that are of a more summary nature. Even in these Toesca notes 'features of a distant antiquity . . . A great simplicity of narrative that calls to mind the simplicity of the early Christians', comparing them in a sense with the style of the Arch of Constantine.

THE EARLY MIDDLE AGES

In 568 the Lombards under Alboin put an end to Justinian's temporary reconquest and spread throughout Italy, where new barbarian dukedoms were formed alongside the remnants of Byzantine power. The political unity of the Italian peninsula was now

shattered for the first time since the Roman period, a factor which also had considerable repercussions in the cultural field, resulting in a diversity of language and the creation of different artistic styles, each with their own influence on later Italian painting and sculpture.

Furthermore, whilst Lombard culture obviously could not compete with, and was eventually absorbed by, the more advanced culture of the peoples they conquered, they brought with them certain skills and techniques, notably in the fashioning of images, which had an impact on the so-called barbarian art of the early Middle Ages; for like the very ancient peoples of the steppes, the new barbarian populations also brought with them their own distinctive art forms.

The oriental characteristics of the civilizations of the Scythians, the Sarmatians and the Huns combined with the civilizations of the Celtic and Scandinavian peoples to give rise to a style commonly called Germanic. However, this style is confined chiefly to the field of gold and silverware and to a series of stone reliefs. Painting and architecture remained essentially foreign to these peoples, whose nomadic way of life was not conducive to the production of art works on a large scale.

The representation of the human figure as an inherent major art form declined in importance and, like the representation of animals, was reduced at best to a purely decorative feature. The chief value of this decorative art lies in its novelty of line, taut and lively, flowing instinctively and almost at random through a myriad whorls and loops. This spontaneity of line represents the heritage the barbarians were to leave

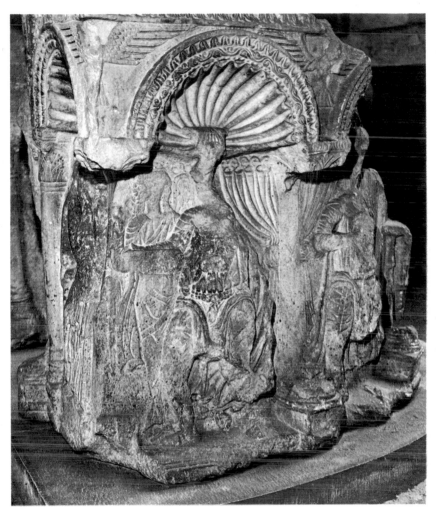

46 *Byzantine art : Madonna and child with angels, detail of an ambo from*
Salonika. V century AD. Istanbul, Museum of Archeology.

46 Byzantine art: *Madonna and child with angels*, detail of an ambo from Salonika. V century AD. Istanbul, Museum of Archeology.
Among the most interesting pieces of Byzantine sculpture are the remains of this grandiose ambo, unhappily much damaged: in the fragment shown here the faces are unrecognizable.

47 Byzantine art: *Head of Arcadius*. AD 383–408. Istanbul, Museum of Archeology.
The so-called head of the Emperor Arcadius is one of the most expressive pieces of all Byzantine art. The conformation of the lower part indicates that the head was originally conceived to be placed on a statue.

48–9 Byzantine art: *Details of mosaic floor*. V century AD. Constantinople, Imperial Palace. In a courtyard of the Imperial palace in Constantinople there has recently been discovered a mosaic floor, of which the surviving areas depict hunting scenes, scenes of country life, groups of buildings and isolated figures.

50 Byzantine art: *Hunting scene*, bronze plaque inlaid with gold and silver. V–VI century AD. Paris, Louvre.
Hunting scenes, which were one of the favourite motifs for floor mosaics, also appear frequently on silver dishes, in woven cloth, on works in ivory and in sculptures.

51 Byzantine art: *Eagle in filigree and rough gold*, from Skäne, Stockholm, Statens Sjöhistoriska Museum. Byzantine taste is also evident in this superb golden eagle, set with jewels and decorated with tiny lumps of gold.

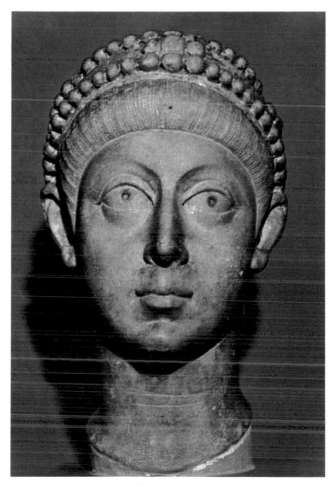

47 *Byzantine art : Head of Arcadius. AD 383–408. Istanbul,*
Museum of Archeology.

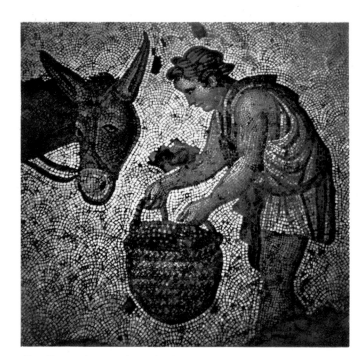

48 *Byzantine art : Details of mosaic floor. V century AD.*
Constantinople, Imperial Palace.

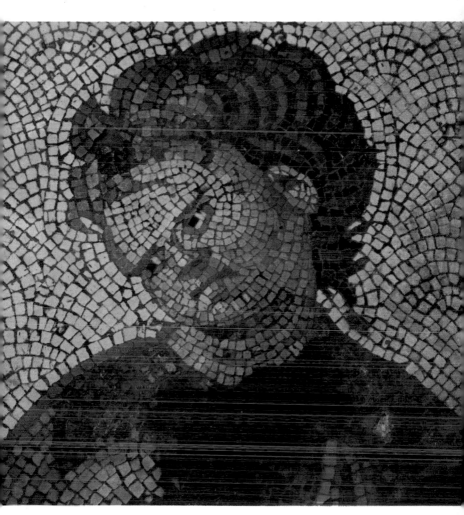

49 *Byzantine art : Details of mosaic floor. V century AD. Constantinople,*
Imperial Palace.

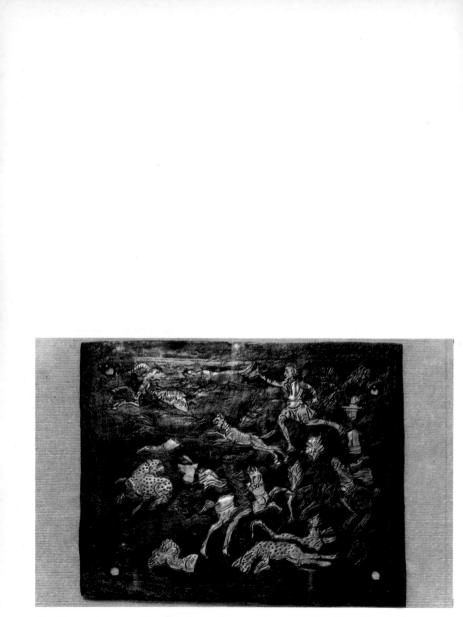

50 *Byzantine art : Hunting Scene, bronze plaque inlaid with gold and silver.*
V–VI century AD. Paris, Louvre.

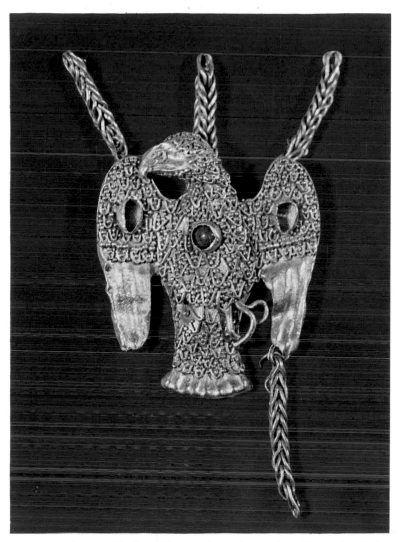

51 *Byzantine art : Eagle in filigree and rough gold, from Skåne, Stockholm, Statens Sjöhistoriska Museum.*

to the new art forms of medieval Europe. Many peoples, often of uncertain origin, mingled and moved across Europe in these centuries in successive waves of immigration. They left their traces in Germany, in Scandinavia, in England, in Rumania and in Italy, where the Lombard contribution is richly represented in the field of gold and silverware, examples being the splendid cross and helmet of Agilulf, and the bronze fibula of Cividale which is very similar to the gilded clasps of Öland.

Around the fifth century, in the Scandinavian regions of Europe's far north, Germanic sculpture was superimposed on Celtic and Roman sculpture. Among the most curious and interesting objects produced at this time were the runic stones. The runes are the graphic characters peculiar to the Germanic world which were to reach their most widespread diffusion in the Scandinavian countries. We know hardly anything about the earliest runic inscriptions, which must have been inscribed on wood; but it is certain that the eastern and then the southern Germans also carved such inscriptions on bone and metal, while in Norway and Sweden we find the same incisions on rock faces and tombstones. In addition to writing, there are also delightful drawings, possibly containing mysterious significance.

In the East, the flight from Medina in 622 heralded the Mohammedan era. The expansion of Islam quickly engulfed both the Persian kingdom of the Sassanids and the provinces of the Byzantine Empire (Persia fell in 653, Mesopotamia in 636, and the Arabs conquered Egypt in 641), swamping their cultural tradition as well as their territories. In Egypt early Christian art had

acquired a particular form known as Coptic art, and often characterized by exquisitely decorative motifs. Among the most original and inventive of the Coptic creations were their woven fabrics. The designs are lively and subtle, often of animals face to face, framed in geometrical squares and surrounded by a variety of decorations. The same harmony and good taste are found in the ornamental motifs that decorate plates and metal objects, in wood carvings, and in the various articles that comprise the so-called minor and applied arts. Coptic art, which flourished mainly in the fifth and sixth centuries, naturally declined after the invasion of the Arabs, who spread the Islamic civilization throughout the region.

In Persia the Graeco-Persian art which was the fruit of the marriage of Achaemenian civilization and Hellenistic culture produced no works worthy of particular attention. In the third century BC the Parthians invaded the entire region of Persia and established a strong kingdom that even held out victoriously against the expanding Roman Empire. During the rule of the Parthians the art of Persia was gradually modified, changing from the Graeco-Persian to the Neo-Persian style, which more closely reflected local tradition and in some ways heralded the rebirth of the ensuing Sassanid period. Naturally, Hellenistic elements, as well as Roman, were discernible in Parthian art, but they have percolated through a different education and mentality which wrought profound changes. Parthian art reflected the meeting of the Middle and the Far East with the Graeco-Roman spirit, as was to happen in the Gandhara civilization in India.

A minor prince of the province of Fars, Ardeshir Papakan, succeeded the Parthian dynasty in 226 AD, and inaugurated the period of the Sassanid kings who reigned over Persia for four centuries, restoring the splendour of the Achaemenian period. With a series of victorious campaigns the Sassanid kings extended their empire, bringing back to their country thousands of prisoners from the Graeco-Roman provinces, who introduced aspects of their own civilization into the new Persian culture. This contact with the West is clearly reflected in the palaces, mosaics, sculptures and stucco-work of the Sassanid period. Nevertheless, forms of art persisted that were genuinely Persian, so strong was the spirit and the thought behind them. Once again art exalts the king, glorifying his deeds and extolling his power. The art of the Sassanid period is a pure expression of magnificence, grandeur and wealth, and its core is invariably the sovereign. His idealized features constantly appear in bronze busts, palaces are dedicated to him, his royal hunts are vigorously depicted in heavily embossed relief, as in the decoration of gold and silver plates. The most common motifs and images in Sassanid art are of a symbolic nature, although as has already been noted in the Achaemenian reliefs, there is tremendous realism in the animal figures, the favourite subject of Persian artists. The landscape, on the other hand, is mechanical and abstract, used purely for decorative effect.

Sassanid art had widespread influence on both the Eastern and Western worlds. The precious Sassanid fabrics gave fresh impetus to the Coptic cloths. The magnificent gold and silverware of the Chosroes period was known and copied by the Carolingians, as it was

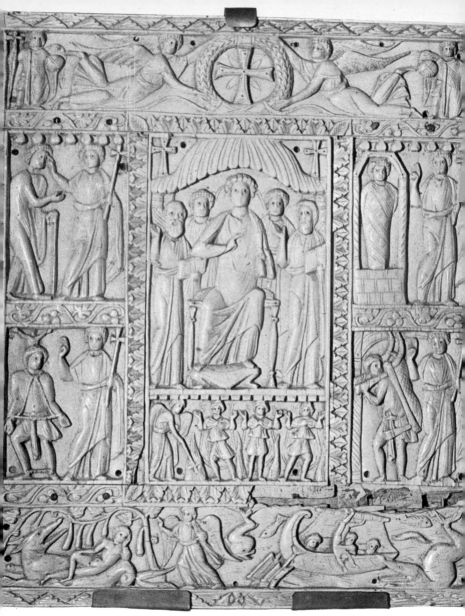

53 *Byzantine art (?) : Murano diptych. VI century AD. Ravenna,*
National Museum.

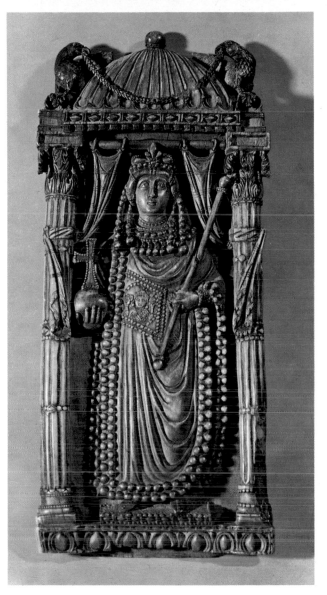

54 *Byzantine art : Empress Arianna (?), Little door in an*
ivory diptych. c. AD 500. Florence, National Museum
(Bargello).

52 Byzantine art: *The so-called Ariadne*, relief in ivory. *c*. AD 500. Paris, Cluny Museum.
Made during the wave of Hellenistic-inspired classicism, this female figure is identified with Ariadne.

53 Byzantine art (?): *Murano diptych*. IV century AD. Ravenna, National Museum.
This work in ivory, depicting scenes from the Old and New Testaments, possibly constituted the cover of an evangelarium.

54 Byzantine art: *Empress Arianna* (?), little door in an ivory diptych. *c*. AD 500. Florence, National Museum (Bargello).
Clad in a rich garment, the Empress of Byzantium stands stately and motionless, bearing the emblems of power.

55 Byzantine art: *Capital with monogram of Justinian I*, from the Church of Santa Sophia in Istanbul. AD 532–7.
The precious marble capitals add to the general impression of magnificence and wealth in Santa Sophia.

56 Byzantine art: *Church of Santa Sophia* in Istanbul. AD 532–7.
Byzantine architects created their greatest work in Santa Sophia, constructed by Isidorus of Miletus and Anthemius of Tralles at the beginning of the reign of Justinian.

57 Byzantine art: *Interior of the Church of Santa Sofia*, in Istanbul. AD 532–7.
The interior of Santa Sophia is a harmony of curvilinear rhythms culminating in the cupola of the main nave.

58 Byzantine art: *Plates in raised silver with scenes from the life of David*, *c*. AD 600. New York, Metropolitan Museum of Art. Gift of J. Pierpont Morgan 1917.
One of the most beautiful pieces among the treasure found on the island of Cyprus are these plates with the figures of David and Goliath.

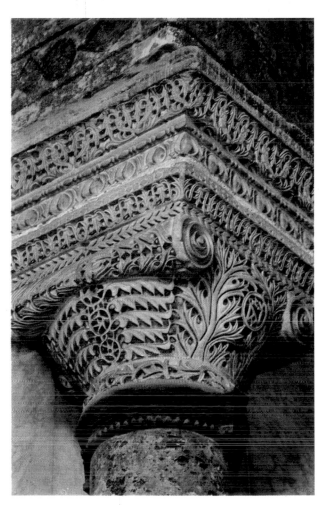

55　*Byzantine art : Capital with monogram of Justinian I. from the Church of Santa Sophia in Istanbul. AD 532–7.*

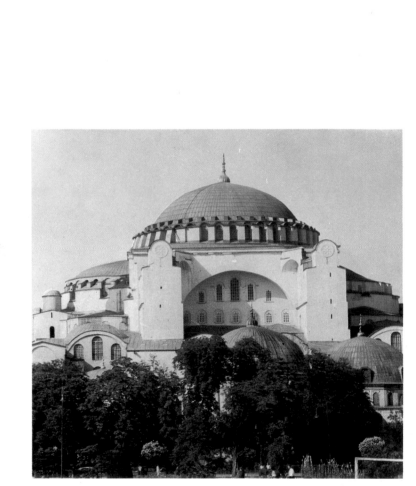

56 *Byzantine art : Church of Santa Sophia in Istanbul. AD 532–7.*

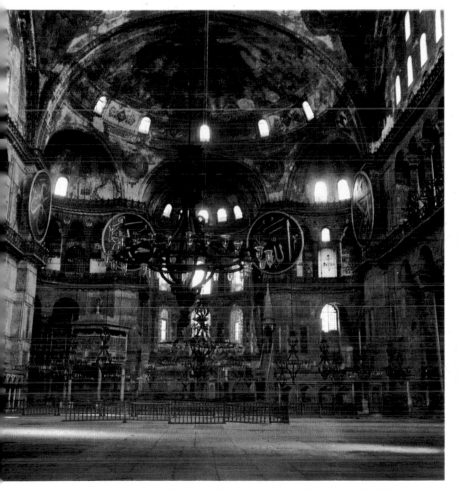

Byzantine art : Interior of the Church of Santa Sophia in Istanbul. AD 532–7.

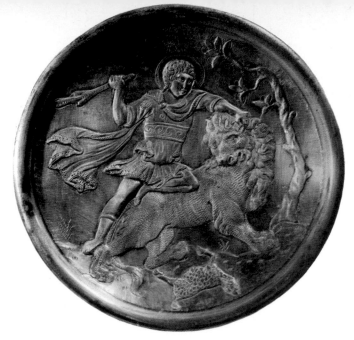

58 *Byzantine art : Plates in raised silver with scenes from the life of David, c. AD 600. New York, Metropolitan Museum of Art.*

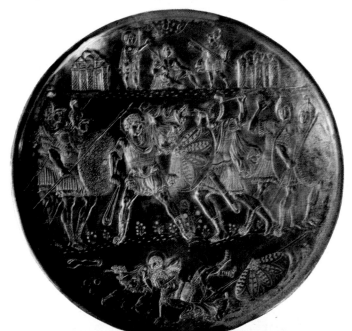

by the barbarians of the Asiatic Steppes. The ornamental motifs so imaginatively devised by the Sassanids suggested many images to Byzantine and subsequently to Pre-Roman and Roman art. In the seventh century the last of the Sassanid Kings fled to China with his court, thus carrying the elements of this prodigious artistic flowering to the Far East as well.

In eighth-century Byzantium the iconoclastic disputes, that had flourished among the intellectual minority since the fourth century, now affected the court too, intent on reasserting Imperial authority over the excessively powerful clergy and monastic orders. The first important iconoclastic art of the Isaurian Emperor Leo III was the destruction of the figure of Christ above the main entrance to the Imperial palace. An inscription placed there by order of the Emperor explained the reasons for such a measure: 'The Emperor cannot tolerate the representation of Christ as a dumb and lifeless image stamped on earthly matter. But Leo and his young son Constantine will hang over their gates the sign of the Holy Cross, the glory of believing monarchs'. The iconoclastic struggle assumed an especially bitter and bloody character under Constantine V (740–75), who ordered the destruction of all the images in every church in Constantinople. 'Everywhere, in every church, the images of the saints were destroyed and the shapes of animals and birds were painted in their place', wrote the Byzantine historian Theophanus. After one last upsurge of image-destruction under Theophilus (812–42) Roman orthodoxy was re-established by Theodora, widow of the dead Emperor.

After the storm had spent itself, a determined effort was made in the second half of the ninth century to restore sacred images, probably beginning with the restoration of the Christ above the palace gate, and extending to every church in the capital, from Santa Sophia to SS Sergio e Bacco, and the Holy Apostles. With the re-establishment of orthodoxy' . . . the development of religious art in Constantinople during the Middle Ages was to become inseparable from a fixed idiom, and rigid iconographic and aesthetic rules dictated by the ecclesiastical authorities supported by royal patronage.' Eliminating 'the non-essential and accidental', art was to 'reflect the Intelligible Being and not represent the fanciful imaginings of mankind'. For this reason it was no longer considered necessary 'to follow direct observation of nature, which would condition the personal vision of the artist: folds and forms became conceptualized' (Beckwith). Under the Macedonian dynasty, which began with Basil I in 867, this 'monitored' art was cloaked with classical forms. This was due to one of the many revivals of Greek forms that occurred, especially during the reign of Emperor Constantine VII, said by historians to have himself been a keen and accomplished painter. This renaissance is clearly evident in illuminated manuscripts such as the Paris Psalter, the Bible of Leo the Patrician, and particularly in the Vatican Joshua. The classical revival did not, however, succeed in lending much vivacity or originality to Byzantine art, and was basically confined to transposing 'the ideal forms of the past into the ideal forms of their own day'.

Objects such as gold and enamelware were made by

Court craftsmen for royal use and were predictably very splendid. An example of this magnificence is the golden altarpiece of San Marco in Venice which is studded with small inlays of Byzantine enamelware of various periods (from the tenth to the thirteenth century) looted from Constantinople at the time of the Fourth Crusade.

In Italy, the Exarchate of Ravenna, last stronghold of Byzantine power, was artistically very conservative, but the legacy of the great fifth- and sixth-century models which the craftsmen of Ravenna were trying to conserve now took on an even more sketchy and impoverished appearance. By the eighth century Rome was well on the way to acquiring a completely autonomous position in the Italian cultural scene. This was facilitated by the special political and religious characteristic of the city, and by the Pope's assumption of the temporal power after the iconoclastic schism which had caused Byzantium to lose even that semblance of political power which the Eastern Emperor had exerted through his ducal representative. In the seventh and eighth centuries the large number of Greek and Syrian popes accounts for the 'oriental' aspect of so much of the Roman art of the period. The mosaics dating from 625–38 in the apse of Sant' Agnese, depicting the saint between Pope Symmachus and Pope Honorius I are especially reminiscent of the Justinian panels in San Vitale, both in subject and coloration. According to the remarkable Latin inscription the colour was the most important element for the artist responsible for the mosaics. In the surviving fragments of the Vatican Oratory (the Madonna now in the San Marco in Florence, the

Madonna in the Cathedral in Orte, the Adoration of the Magi in Santa Maria in Cosmedin, the Saviour in the Vattican Grottoes) built by Pope John VII (705–7) and destroyed in 1606 by Pius V, we can also see 'a sensual pattern of decoration, achieved by small patches of colour, a detailed myriad of freely-changing hues' (Galassi).

The basilica of Santa Maria in the Forum is in many ways a record of early medieval Roman painting, where we can see an accumulation of the various pictorial trends of that period. Although the painting of San Abbaciro (a miracle-performing saint whose cult was brought to Rome from Alexandria in the seventh century) strongly resembles the Coptic paintings of

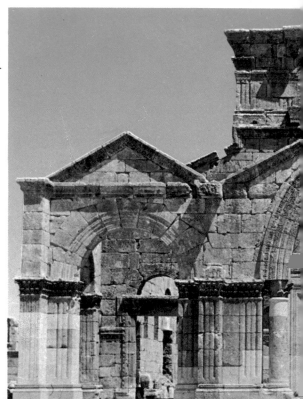

59 *Byzantine art : South entrance to the Basilica of Saint Simeon lo Stilita. AD 476–90. Qalaat Seman.*

Bauit and Saqqarah, and the Egyptian icons depicting patron saints and miracle workers, others are more classical in character, such as the fragment of an angel in the Annunciation. The decoration of the presbytery, depicting figures of apostles, stories from the life of Jesus and (on the end wall above the apse) the Adoration of the Cross, dating from the time of John VII, are in the kind of classical style that almost seems to echo 'the Hellenistic style of primitive Christian art in the East' (Toesca). Not unlike the frecoes in the presbytery are those in the chapel of SS Quirico e Giulitta, which date from the time of Pope Zacharias (741–52). The Crucifixion is on rather Byzantine lines, markedly influenced by local characteristics.

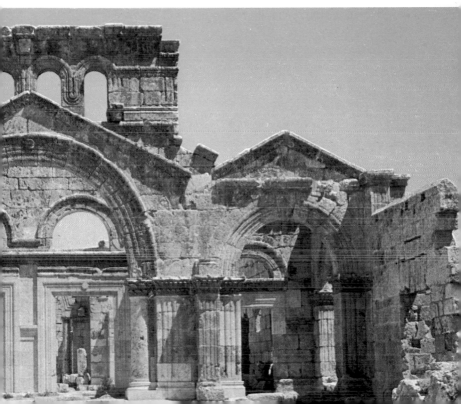

59 Byzantine art: *South entrance to the Basilica of Saint Simeon lo Stilita.* AD 476–90. Qalaat Seman.
The Qalaat Seman complex developed around a small central sanctuary which held the column of Saint Simeon. The sanctuary was erected in the time of Emperor Zeno (476–90) and was the most important in all Syria.

60 Byzantine art: *Silk cloth with motif of a quadriga.** Possibly VIII century AD. Paris, Cluny Museum.
This very fine silk in which the body of the Emperor Charlemagne was wrapped after his death is of Byzantine workmanship.
*Chariot drawn by four horses.

61 Persian art: (Sassanid period): *Cameo in sardonyx.* IV century AD. Paris, Cabinet des Medailles in the Bibliothèque Nationale.
This cameo is thought to commemorate the victory of King Shapur over the Roman Emperor Valerian.

62–3 Persian art (Sassanid period): *Plate in silver with 'senmurv'.* Copenhagen, Ny Carlsberg Glyptotek, and *Plate in silver with King Peroz hunting ibex.* New York, Metropolitan Museum of Art. Fletcher Fund 1934.
Few civilizations can boast of having reached the magnificence of jewellery and silverware of Sassanid craftsmanship.

64 Persian art (Sassanid period): *Bust of king in bronze.* VI–VII century AD. Basle, Borowski Collection.
This Sassanid bronze bust strongly suggests a Persian king of the sixth to seventh century AD.

65 Persian art (Sassanid period): *Plate in silver with hunting scene.* VI–VII century AD. Teheran, Foroughi collection (above) and *Silver bowl in the shape of a small boat.* Baltimore, the Walters Art Gallery (below).
The figure of the King is often prominent in Sassanid decorative work: on the plate he is depicted intent on his favourite pastime, hunting; on the bowl he is depicted seated upon his throne.

60 *Byzantine art : Silk cloth with motif of a quadriga. Possib. VIII century AD. Paris, Cluny Museum.*

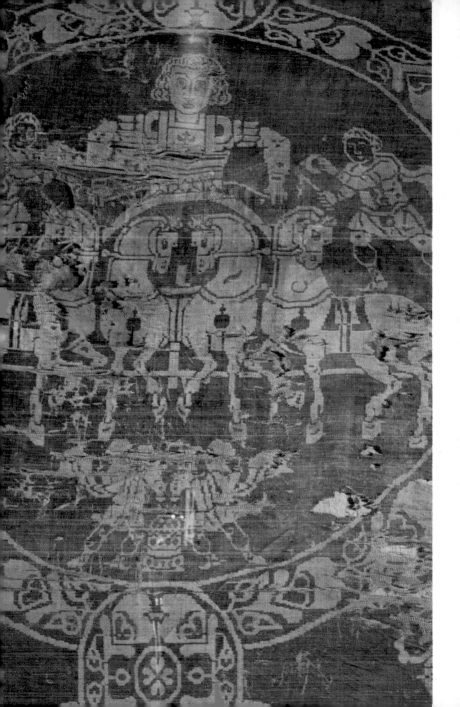

61 *Persian art :*
(Sassanid period) :
Cameo in sardonyx. IV
century AD. Paris,
Cabinet des Medailles in
the Bibliothèque
Nationale.

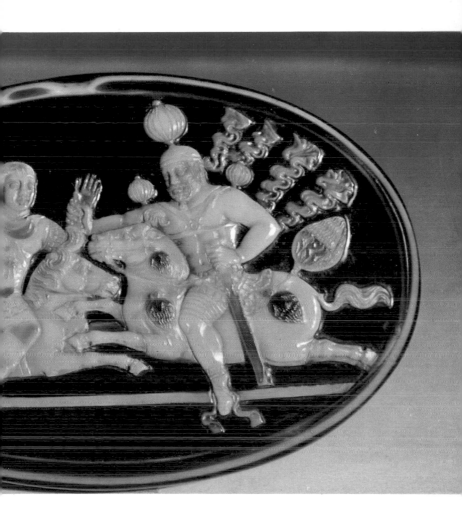

62–3 *Persian art (Sassanid period) : Plate in silver with 'senmurv'. Copenhagen, Ny Carlsberg Glyptotek, and Plate in silver with King Peroz hunting ibex. New York, Metropolitan Museum of Art.*

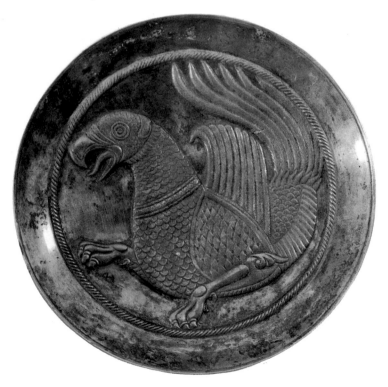

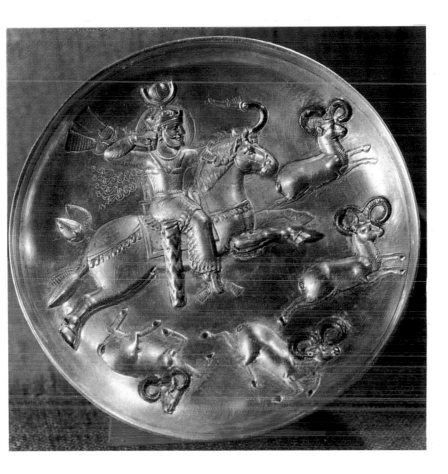

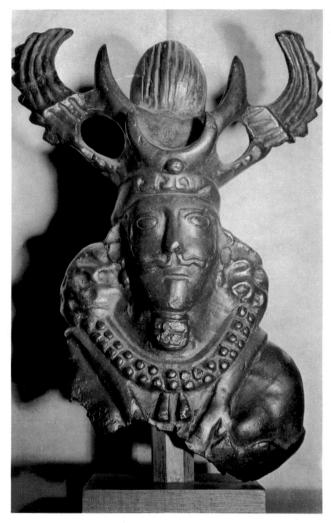

64 *Persian art (Sassanid period) : Bust of king in bronze.*
VI–VII century AD. Basle, Borowski Collection.

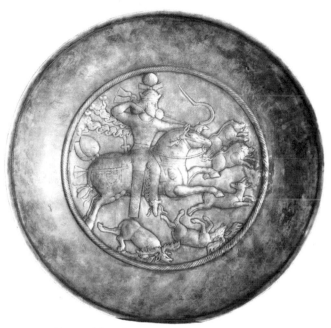

65 *Persian art (Sassanid period) : Plate in silver with hunting scene. VI–VII century AD. Teheran, Foroughi collection (above) and Silver bowl in the shape of a small boat. Baltimore, the Walters Art Gallery.*

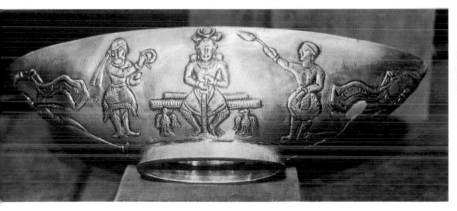

The dominant Lombard culture showed a preference for flattened forms and a proliferation of highly ornamental decoration which reflects both barbarian and oriental features (probably deriving from fabrics). This culture is seen at its best in certain eighth-century sculptures such as the Sarcophagus of Theodota in the Pavia Museum, or the screen of the patriarch Signaldo in the Church of Cividale. Of a more barbaric character, and in fact quite far removed from the elegance of the Sarcophagus of Theodota, is the altar of Duke Rachis, also in Cividale, the richest centre of Lombard works in Italy. In the most famous of these, the little Lombard temple within the Church of Santa Maria in Valle, can be seen part of a stucco-work frieze of saints that has a truly Byzantine flavour.

The Lombard king Rothari who in 643 issued an Edict – the first codification of Lombard law – mentioned the comacine masters as being sculptors and architects of merit. They were the heirs of the great Lombard tradition of early Christian builders and to these travelling craftsmen we owe the oldest parts of San Salvatore in Brescia, the Baptistry of Lomello and perhaps also San Pietro in Toscanella.

On Christmas night in 800, in the Basilica of Saint Peter, Charlemagne was crowned Emperor. Such a ceremony must have appeared to his contemporaries, at least to the intellectual class, as an attempt to revive the Western Roman Empire with its political structure and culture. It was no accident that the Carolingian era witnessed the most serious attempt in the West at a classical revival, centred in the Palace School, founded by Charlemagne in 782 at a court which was to become the cultural and intellectual centre of the Empire.

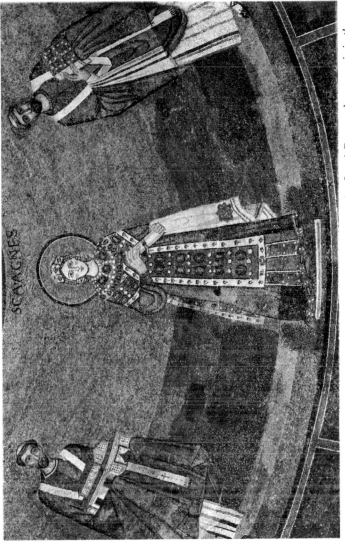

SCAVAGNES

66 Italian art (early Middle Ages) : Sant' Agnese between Honorius I and Symmachus, mosaic in the apse of the Church of Sant' Agnese in Rome. VII century.

111

67 *Italian art (early Middle Ages) : Crucifixion, fresco in the Chapel of SS Quirico e Giulitta. VIII century, Rome, Church of Santa Maria Antiqua.*

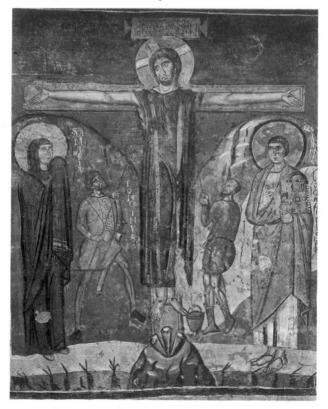

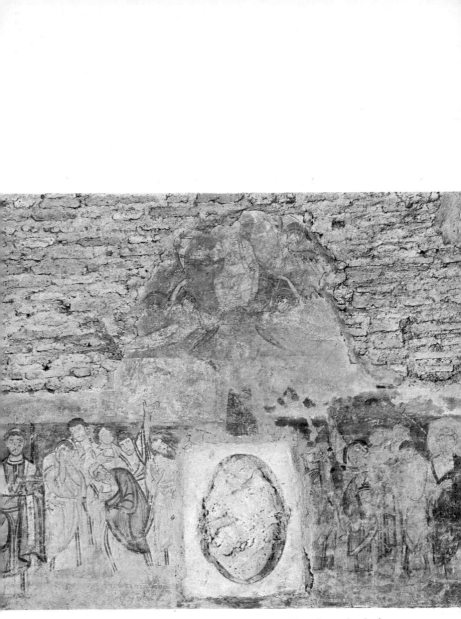

68 *Italian art (early Middle Ages) : The Ascension, fresco in the lower Basilica of San Clemente in Rome. IX century.*

66 Italian art (Early Middle Ages): *Sant' Agnese between Honorius I and Symmachus*, mosaic in apse of the Church of Sant' Agnese in Rome. VII century. In the figures this luminous mosaic reflects the strong influx of Byzantine art which continued in Italy between the sixth and eighth centuries.

67 Italian art (early Middle Ages). *Crucifixion*, fresco in the Chapel of SS Quirico e Giulitta. VIII century, Rome, Church of Santa Maria Antiqua. The frescoes in the Church of Santa Maria Antiqua show Byzantine features combined with others of directly classical tradition. This Crucifixion is particularly noteworthy.

68 Italian art (early Middle Ages): *The Ascension*, fresco in the lower Basilica of San Clemente in Rome. IX century.

69 *Byzantine art (early Middle Ages): Anointing of David and fight with the bear. c. AD 1020. Venice, Biblioteca Marciana.*

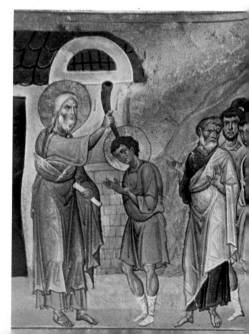

In this large fresco the Byzantine tradition recurs in the revival of Roman classicism.

69 Byzantine art (early Middle Ages): *Anointing of David and fight with the bear. c.* AD 1020. Venice, Biblioteca Marciana.
This illumination is in the Psalter of Basil II Bulgaroctous: the scenes are arranged with traditional iconography.

70 Italian art (early Middle Ages): *Christ Triumphant,* mosaic in the Shrine of San Zenone. IX century. Rome, Basilica of San Prassede.
From the top of the cupola Christ triumphant dominates the other figures in the mosaic disposed in a rigidly neat arrangement around him.

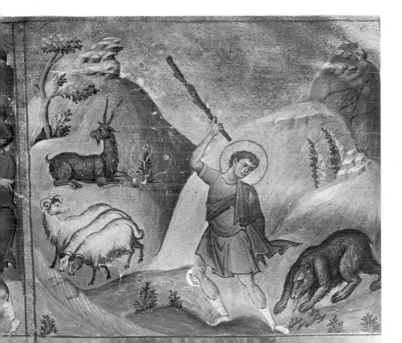

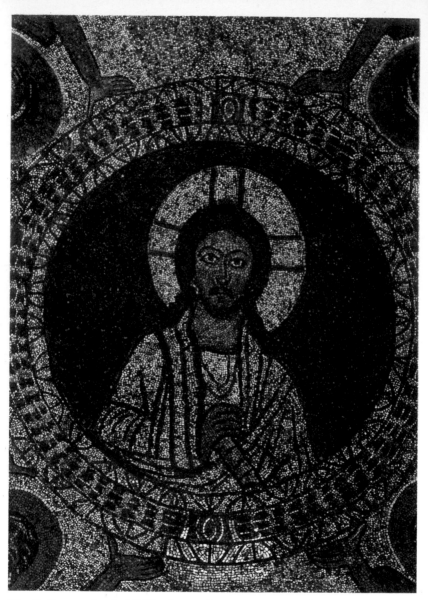

70 *Italian art (early Middle Ages) : Christ Triumphant mosaic in the Shrine of San Zenone. IX century. Rome, Basilica of San Prassede.*

A clear example of this 'revival' is the Palatine Chapel of Aachen, similar in ground plan to San Vitale in Ravenna. The Torhalle of Lorsch is far more original however, a small building which formed part of a church consecrated by Charlemagne and his wife Hildegarde in 775. There is something casket-like in the simplicity and solidity of its form, and the exterior decoration of alternating red and white stones edged with triangular cornices.

Evidence of the same classical trend is to be found in the gold and silverware and illuminated manuscripts produced in the flourishing schools of Aachen, Rheims and Tours. Among the oldest Carolingian manuscripts should be mentioned the Godescalco *evangelarium*, probably dating from between 781 and 783, which reflects both Byzantine and Irish traditions, the latter explained by the fact that Alcuin, the director of the Palace School, was an Irish monk. The embossed or engraved decorations on Carolingian gold and silverware slowly lost their geometrical character and became more figurative. This return to the use of the human form was of the greatest importance. It was no longer used merely as a piece of abstract decoration but again acquired the full value and reality and depth it had known in Hellenistic art. This must have been evident in the triumphal arch of Einhard (which constituted the base of a cross ordered by the Abbey of Saint Servais in Maastricht, and is known only from a drawing), and can be seen in the golden altar of the Basilica Ambrosiana in Milan, made by Vuolvinio for Bishop Angilbert, a Frankish nobleman (824–59). Vuolvinio probably carved the reliefs on the sides and the back that depict scenes from

the life of Saint Ambrose whilst the reliefs on the front, depicting scenes from the New Testament to each side of the big cross in the centre, are attributed to one of his pupils, with a rather livelier style.

The four Holy Roman Emperors named Otto, who succeeded Charlemagne, inherited and absorbed the best of Carolingian civilization, culminating in the High Romanesque style of the eleventh and twelfth centuries. Against a cultural background of a return to late Roman and Byzantine art (evident in the composed solemnity of the illuminated manuscripts of the Maestro del Registrum Gregorii) a highly expressive style emerged, full of movement and dramatic touches, at times deeply realistic and highly individual. The splendid 'expressionist' *evangelarium* of Otto III in Munich, the Bamberg Apocalypse, the gold and silverware of Cologne, Regensburg, Hildesheim, Fulda, Trier, the bronze doors of Hildesheim Cathedral, all bear witness to the excellence of the art of the Ottonian period. On the other hand in the magnificent Cross of Lothar in Aachen the Hellenistic cameo set at the junction of the arms reminds us that the German Empire was a worthy heir to the Roman Empire.

In early medieval Spain, alongside Islam triumphant, there flourished a humbler Christian civilization under the protection of the Kings of Asturias, especially Ramiro I. Legacies of this civilization include some churches of early Christian form with a crypt (the incorporation of a crypt in the Christian basilica started in the ninth century), and some royal residences, very similar in their structural simplicity to Carolingian architecture. Santa Maria de Naranco,

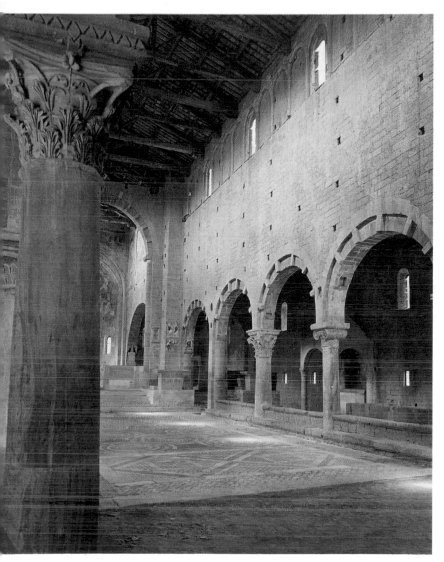

71 *Italian art (early Middle Ages) : Detail of the interior of the Church of Saint Peter in Tuscania.*

119

71 Italian art (early Middle Ages): *Detail of the interior of the Church of Saint Peter* in Tuscania. One of the comacine masters participated in the construction of this church. The building conveys an impression of great strength, and the structure is in many of its features a precursor of future Romanesque forms.

72 Barbarian art (early Middle Ages): *Marble slab from the Sarcophagus of Theodota.* VIII century. Pavia, Museo Civico.
Ornamental sculpture acquired a new importance in the early Middle Ages: an example is this sarcophagus with its combination of allegorical Christian imagery and motifs of barbarian art.

73 Italian art (early Middle Ages): *Decoration in stucco-work*, detail of the interior of Santa Maria in Valle in Cividale del Friuli. This small temple, a building of disputed date, is known especially for the admirable stucco-work that decorates the interior.

72

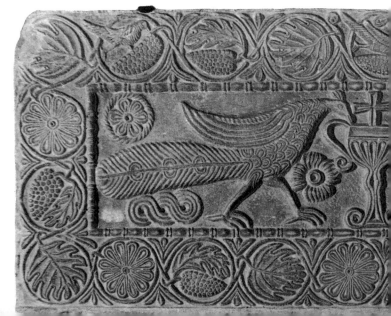

74 Italian art (early Middle Ages): *Flight into Egypt*, fresco in the church of Santa Maria Foris Portas in Castelseprio. End of VIII century (?). The style of the Castelseprio frescoes is different from that of other wall paintings of the same period and stems directly from the classical tradition, of which it is a noble and worthy example.

75 Art of the Asturias (early Middle Ages): *Santa Maria de Naranco*. AD 842–50. Oviedo.
This building is perhaps the only surviving example of a royal residence. Built at the order of Ramiro I, King of Asturias, it consists of a single rectangular hall built over a crypt.

76 Italian art (early Middle Ages): *Biella Baptistery*. The apparently primitive simplicity of the Biella Baptistery belies an architectural sensitivity particularly evident in the skilled complexity of its trefoiled ground plan.

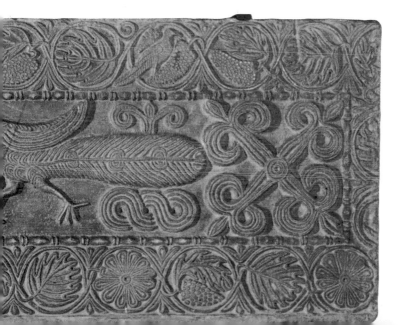

73 *Italian art (early Middle Ages) : Decoration in stucco-work, detail
of the interior of Santa Maria in Valle in Cividale del Friuli.*

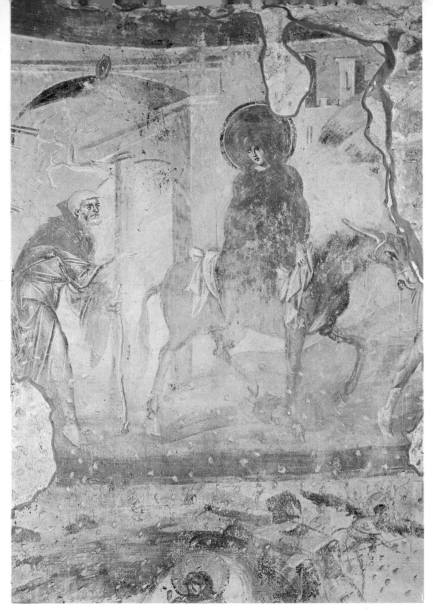

74 *Italian art (early Middle Ages) : Flight into Egypt, fresco in the church of*
Santa Maria Foris Portas in Castelseprio. End of VIII century (?).

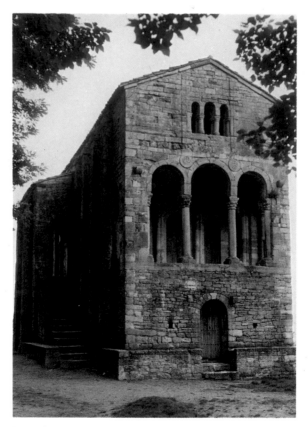

75 *Art of the Asturias (early Middle Ages) : Santa
Maria de Naranco. AD 842–50. Oviedo.*

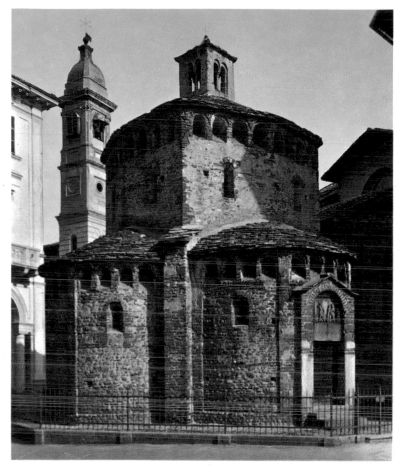

76 *Italian art (early Middle Ages) : Biella Baptistery.*

near Oviedo, once a royal residence and subsequently made a church, is one of the best known.

The region of Italy in closest contact with Carolingian and Ottonian culture was obviously Lombardy, which possesses the best examples of Carolingian gold and silverware. There was much cultural intermingling in these regions, even if today it is hard for us to appreciate the variety, wealth and spiritual complexity of the artistic milieu of that period, because what has survived is certainly only a tiny part of the work produced at that time. It is also difficult to understand the perpetuation of certain aspects of ancient 'realism' ('a feeling for life' to use Bologna's words 'which was really handed down from ancient times') that we find in Aosta, in the beautiful fragments of San Pietro ed Orso, and also in Münster and Malles. In these and the Carolingian illuminated manuscripts known as the Ada manuscripts, as well as the superb frescoes of Santa Maria Foris Portas in Castelseprio (frescoes of disputed date but probably not later than the eighth century), the Hellenistic tradition is more evident than elsewhere. This very real survival of the ancient spirit is still clearly perceptible even in the surroundings of Benevento, in the frescoes of Santa Sophia in Benevento, that possibly date from the end of the eighth century, and in the frescoes of San Vincenzo al Volturno dating from 826–34 (the period of Abbot Epiphanius who commissioned them). In these 'the sense of human striving' is warmed by 'a burning passion' in contrast to the frescoes of Santa Sophia in Benevento, where the 'controlled sense of greatness and majesty has not yet given way to forceful expression' (Bologna).

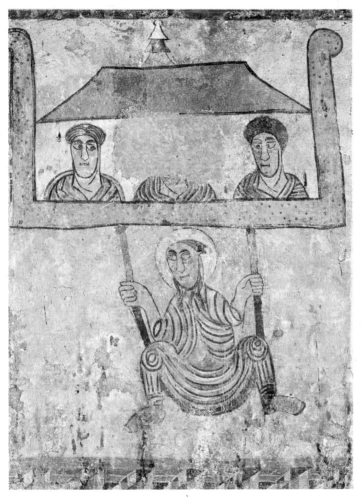

77 *Italian art (early Middle Ages) : The flight of St Paul from Damascus, fresco in the Church of San Procolo in Naturno. c. IX century AD.*

77 Italian art (early Middle Ages): *The flight of St. Paul from Damascus*, fresco in the Church of San Procolo in Naturno. *c.* IX century AD. These frescoes are noteworthy for their originality of style which seemingly ignores classical tradition. The saint is depicted as he lets himself down the wall.

78 Irish art: *Monogram XPI*, illumination from the Book of Kells. *c.* AD 800. Dublin, Trinity College Library. The art of illumination reached full and magnificent maturity in Ireland in the seventh century.

79 Anglo-Saxon art (early Middle Ages): Saxon tower, *c.* AD 1100. Earl's Barton, Northamptonshire. The particularly characteristic feature is the slender pilasters which combine to suggest a delicate effect of arcades.

80 Anglo-Saxon art (early Middle Ages): *Church of Saint Lawrence*. VII–X century AD. Bradford-on-Avon, Wiltshire.
This is one of the oldest buildings in England. The severity of the exterior is relieved by a series of small blind arches.

81 Carolingian art: *The great portico of the Imperial Abbey of Lorsch*. Second half of VIII century AD.
Next to the Palatine Chapel, this ancient imperial abbey is the most important work of Carolingian architecture. The façade is covered alternately with red and white stones.

82 Carolingian art: *Palatine Chapel at Aachen*. AD 798–805.
Built by the architect Einhard, the concept and structure of this chapel owe much to the Basilica of San Vitale in Ravenna.

83 Carolingian art: *Detail of the Godescalco Evangelarium*. AD 781–3. Paris, Bibliothèque Nationale.
This *evangelarium* is the oldest of the Palatine group of manuscripts. Alongside traditional Byzantine features can be seen others of Irish, or at all events, barbarian origin.

78 *Irish art: Monogram XPI, illumination from the Book Kells. c. AD 800. Dublin, Trinity College Library.*

hGeneratio

79 *Anglo-Saxon art (early Middle Ages) : Saxon tower c. AD 1100.*
Northamptonshire, Earl's Barton.

80　*Anglo-Saxon art (early Middle Ages) : Church of Saint Lawrence.
VII–X century AD. Wiltshire, Bradford-on-Avon.*

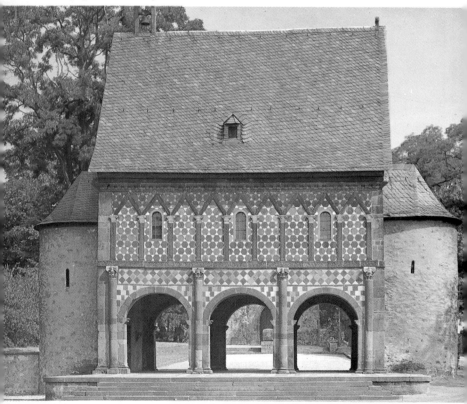

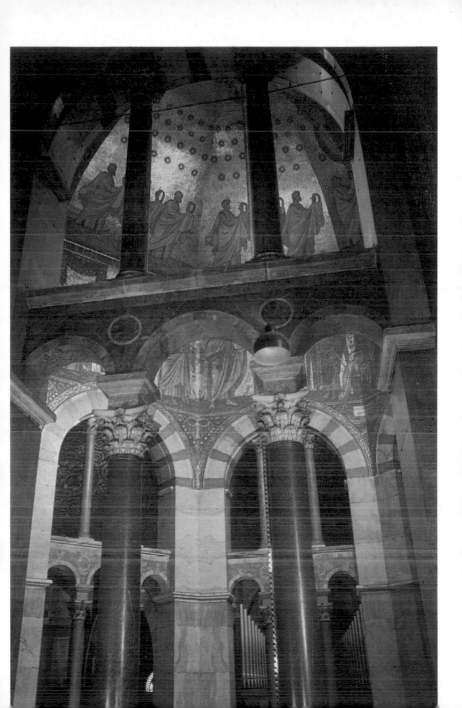

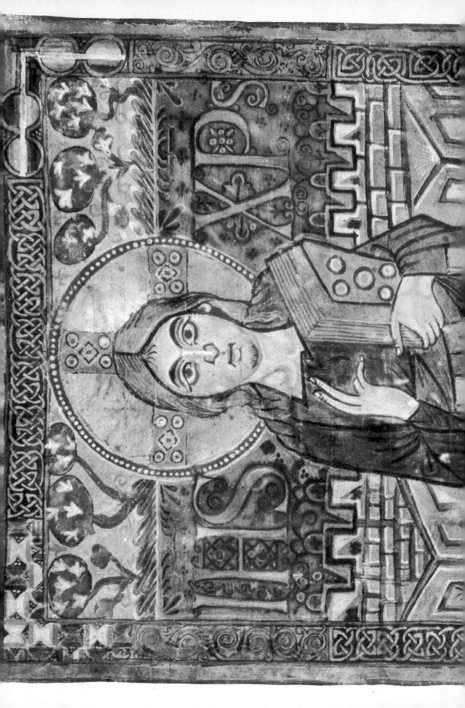

83 *Carolingian art : Detail of the Godescalco Evangelarium. AD 781-3. Paris, Bibliothèque Nationale.*

It has often been assumed that an important influence on these aspects of Northern and Southern art was the strong tradition of Syriac culture, which more than any other passionately and devotedly upheld the values of the ancient world and was, one might say, the well from which Western culture drew its inspiration.

In Lombardy too the frescoes in San Vincenzo in Galliano, which can probably be dated before 1007, and the recently discovered and very similar frescoes in the Baptistery of Novara, both bear a resemblance to the illuminated manuscripts of the school of Reichenau (the flourishing centre of monastic life on the Lake of Constance under the Ottos) or to the fiery expressionism of the Cologne illuminations. On the other hand the other great cycle of Ottonian frescoes in Lombardy, that of San Pietro al Monte in Civate, is more subdued and calm, and reflects characteristics of Byzantine art, one of the consistent threads running through the tenth and eleventh century culture. In architecture the progressive departure from early Christian forms is already apparent in the adoption of new techniques, which only the Romanesque was to be able to unite into an aesthetic whole. Architects of the Lombard churches of this period began to adopt the vault with pointed arches (hitherto confined to the crypts) and to enliven the apse with niches. Latium too–now that Rome had grown powerful as a result of her alliance with the Carolingians–embarked upon an important town-expansion programme. Santa Maria in Cosmedin, Santa Prassede, Santa Maria in Domnica and San Marco were all built between the end of the eighth

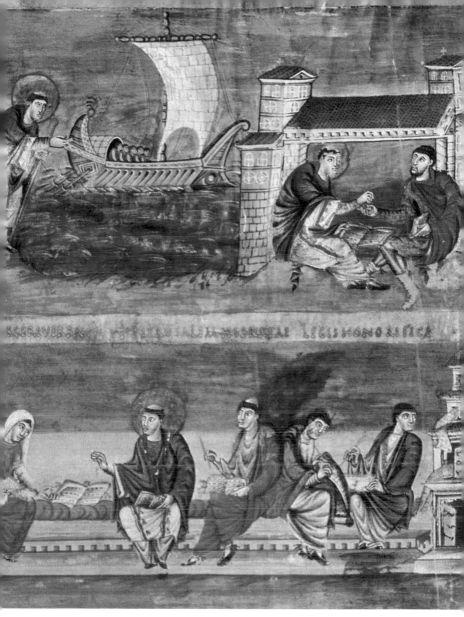

4 *Carolingian art : Detail of the Bible of Charles the Bald or Grandval.*
Paris, Bibliothèque Nationale.

137

84 Carolingian art: *Detail of the Bible of Charles the Bald or Grandval*. Paris, Bibliothèque Nationale.
The detail shows scenes from the life of Saint Jerome: above the saint translating the Bible and leaving Rome for Jerusalem; below, working with the scribes.

85 Art of the Ottonian period: *Evangelarium of Otto III, St Luke. c.* AD 1000, Munich, Bayerische Staatsbibliothek.
Among the most amazing creations of Ottonian art are the four figures of the Evangelists each stoutly holding aloft his respective symbol, surrounded by heads of prophets.

86 Italian Romanesque: *Mosaic in the apse of the Upper Basilica of San Clemente* in Rome. *c.* AD 1128.
The great mosaic decoration in the bowl of the apse shows a revival of the Early Christian style, particularly in the symmetrical arrangement of the composition.

87 German Romanesque: *Detail of the bronze doors of Bernward. c.* AD 1015. Hildesheim Cathedral.
The name of Bishop Bernward, artist and patron, is linked with the bronze doors of Hildersheim, cast in 1015 and ceremonially opened in 1035. They are a remarkable pictorial Bible, depicting scenes that range from the Creation to the Resurrection.

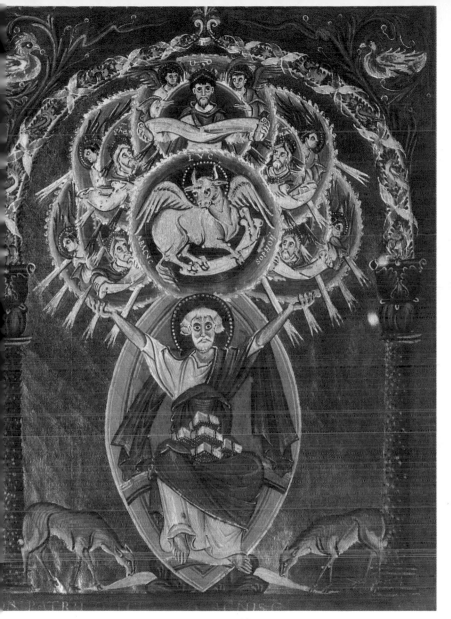

85 *Art of the Ottonian period : Evangelarium of Otto III, St Luke. c. AD 1000.*
Munich, Bayerische Staatsbibliothek.

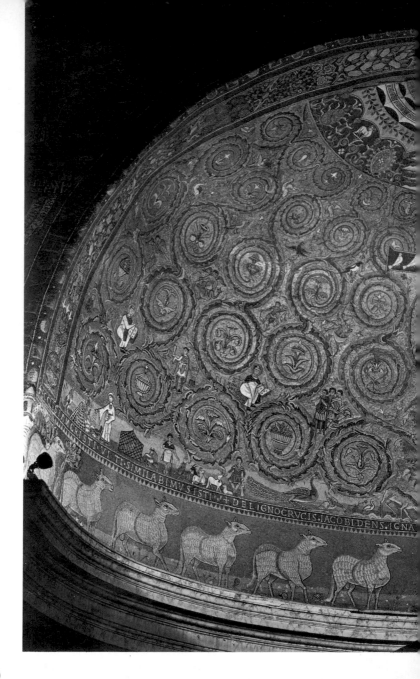

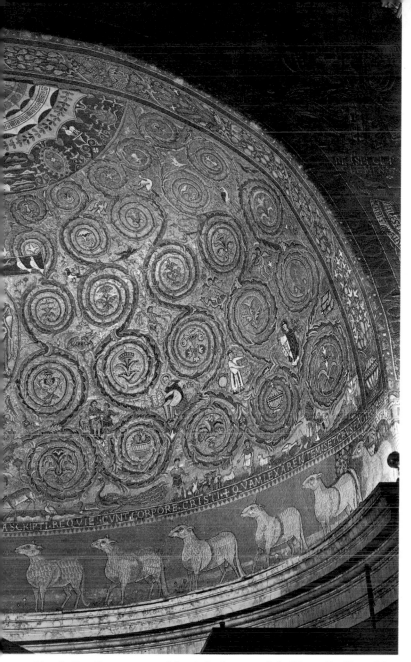

86 *Italian Romanesque : Mosaic in the apse of the Upper Basilica of San Clemente in Rome. C. AD 1128.*

87 *German Romanesque : Detail of the bronze doors of Bernward. c. AD 1015. Hildesheim Cathedral.*

and the first half of the ninth century; and the church of Saint Elia near Nepi combines many of these Lombard innovations.

The South of Italy, on the other hand, followed more in the Byzantine tradition. Abbot Desiderius had artists brought from Constantinople to modernize the abbey of Montecassino, completed in 1071. This marked the introduction, in Campania, of a courtly kind of Byzantine painting, evident in the illuminated manuscripts as in the frescoes of Sant' Angelo in Formis, where the angel in the lunette over the entrance, for example, is the forerunner of a new wave of Byzantine contributions in the following century.

In Rome too, as in Montecassino, the influence of Byzantium is predominant (the mosaics of Santa Maria in Domnica, of Santa Prassede with the shrine of San Zenone, and of San Marco) although running through the fabric of Byzantine culture there are also threads of classicism. Examples are the scenes from the life of St. Clement in the church of that name (dating from the end of the eleventh and early twelfth centuries), which Toesca finds reminiscent of sixth-century cloth or Hellenistic murals, and the apse mosaics of the same church in which 'among the shoals of Byzantine-type images, although only of secondary importance, the plant motifs that decorate the early Christian apse of the Lateran Baptistery have become more than mere draughtsmanship and are in fact a masterpiece of their own kind' (Bologna). In the early Middle Ages there was also a cultural revival in the Anglo-Saxon world reflected in the field of architecture by buildings in the Carolingian style, precise and elegant in their simplicity, and above all in

the realm of gold and silverware and illuminated manuscripts.

The illumination of manuscripts dates back to ancient times: it was known in Egypt, for example, under the Pharaohs. Illuminated sacred books were already circulating in the fourth and fifth centuries on every coast reached by the Christian missionaries, but the Irish illuminated manuscripts that flourished around the seventh century nevertheless represent an important new development. They were no longer simply illustrations inserted like pictures on the page, but in fact incorporated the whole page in the decoration, so that the character of the page depended on a standard of illustration and design which was to hold good right up to the present day. The copyist and the illustrator were often one and the same person, so that the resultant text and illustration were closely linked. The initial letter of the page became enormous, decorated with trailing motifs and twirls that often ended in animal heads and are strongly reminiscent of the rich ornamentation so typical of the gold and silverware. Numerous illustrated texts of this Irish type have been found in other countries, brought there by monks on their pilgrimages who thus contributed to the birth of the various schools of illumination during the Carolingian era. It is important to note how the so-called Germanic style continued to flourish in different forms in areas as widely separated as Ireland, Lombardy, Italy and Scandinavia.

88 *Italian Romanesque: The Elect, detail from the Universal Judgment in the Church of Sant' Angelo in Formis near Capua. XI–XIII century AD.*

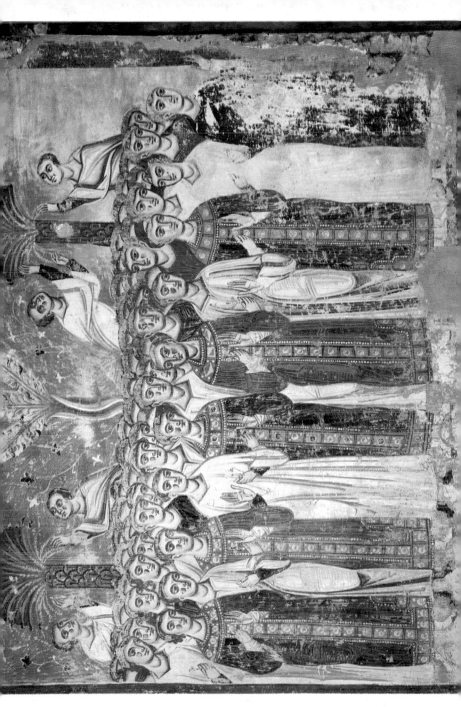

88 Italian Romanesque: *The Elect*, detail from the Universal Judgment in the Church of Sant' Angelo in Formis near Capua. XI–XIII century AD.
In the frescoes that decorate the Church (and the execution of which covered two centuries, from the eleventh to the thirteenth), we can see the elegance and expressive conventionality that are the principal characteristics of the waning Byzantine tradition.

89 Italian Romanesque: *Vision of the Apocalypse*, fresco in the Church of San Pietro al Monte in Civate. First half of XII century AD. The contorted forms of the angels and the dynamism of the composition are comparable with the sculpture of the period.

90 Byzantine art: *Detail of the interior of the Church of Saint Luke* in Focide (Greece). X century AD.
Among the most noteworthy monuments of late Byzantine art is the Church of St Luke, decorated with a magnificent series of mosaics which established more popular styles of form.

91 Byzantine art: *Church of Saint Theodore* in Mistra (Greece).
The little city of Mistra, the Christian Pompeii, was a very active centre of the Byzantine cultural revival. The Church of Saint Theodore reverts to the traditional Latin cruciform plan, surmounted by a central cupola.

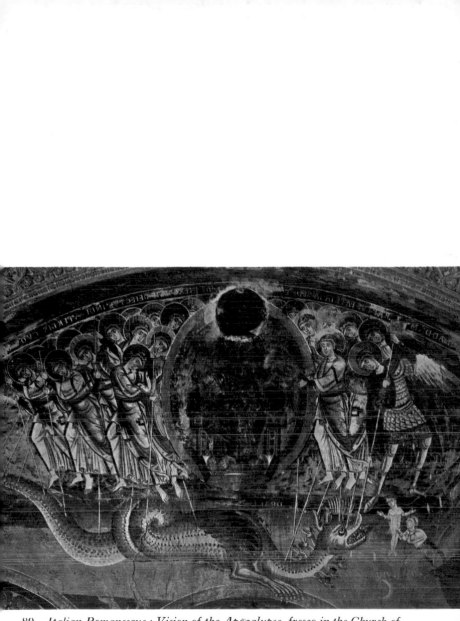

89 *Italian Romanesque : Vision of the Apocalypse, fresco in the Church of San Pietro al Monte in Civate. First half XII century AD.*

90 *Byzantine art : Detail of the interior of the Church of Saint Luke in Focide (Greece). X century AD.*

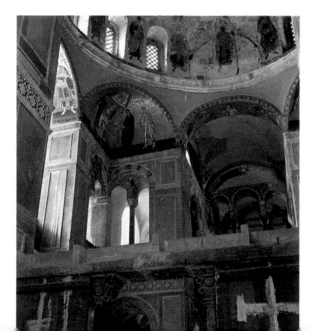

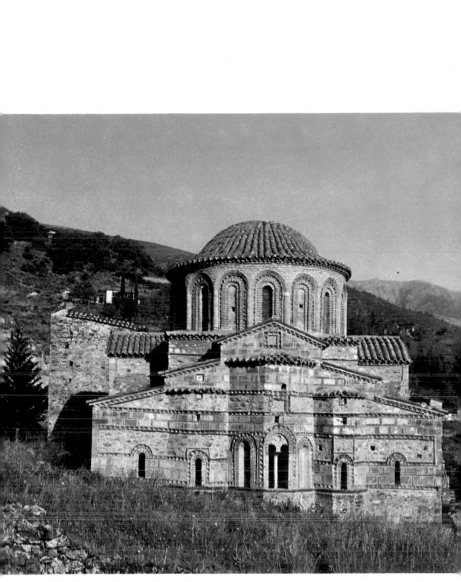

91 *Byzantine art : Church of Saint Theodore in Mistra
(Greece).*

CHRONOLOGICAL TABLE

312: Victory of Constantine against Maxentius at Ponte Milvio.

313: Peace established with the Church.

330: Byzantium capital of the Eastern Empire.

Age of Constantine

Rome: Lateran and Baptistery; Saint Peter's; San Paulo fuori le Mura.

Bethlehem: Church of the Nativity.

Jerusalem: Sanctuary on Golgotha.

Constantinople: Santa Sophia, Holy Apostles (first building).

379–95: Theodosius I Emperor.

380: Edict of Theodosius; Christianity made State religion.

374–97: St Ambrose Archbishop of Milan. Basilica dei Martiri (now Sant' Ambrogio).

384–99: Pope Siricius: Foundation of Santa Pudenziana Rome.

Constantinople: base of obelisk of Theodosius.

End of fourth century: reconstruction of San Paulo fuori le Mura.

395: Permanent division of Eastern and Western Empires.

WEST

404–76: Ravenna capital
Mausoleum of Galla Placidia
Baptistry of Neone (Bishop from 449–59).

Rome: Building of Santa Maria Maggiore (Pope Sixtus III 432–40).

Santa Sabina (Pope Celestine, 422–32).

476: End of Western Empire.

493–526: Theodoric lord of Italy.
Ravenna: Sant' Apollinare Nuovo; Mausoleum of Theodoric.

540: The Byzantines take Ravenna.

542: Consecration of San Vitale.

549: Consecration of Sant' Apollinare in Classe.

556 69: At the time of Bishop Agnello the mosaics of Theodoric's day in the central fascia of Sant' Apollinare Nuovo were replaced.

Sixth century in Rome: Mosaic of SS Cosma e Damiano (Pope Felix IV, 526–30).
Oldest paintings in Santa Maria Antiqua.

568: Lombard invasion.

571: Fall of Ravenna.

Seventh century: Mosaic in the apse of Santa Agnese (625–38).

Eighth century: Santa Maria Antiqua: paintings in presbytery (Pope John VII, 705–7).
Chapel of SS Quirico e Giulitta (Pope Zacharias 741–52).
Castelseprio; Santa Sophia in Benevento.

782: Charlemagne institutes Palace School in Aachen.

Eighth-ninth century: Carolingian art.
Milan: Golden altar of Vuolvinio (824–59 approx.).

Ninth century: Frescoes in San Vincenzo in Volturno.

Rome: Mosaics in Santa Maria in Domnica and Santa Prassede (Pope Pasquale I, 817 24).
Saint Mark's (Pope Gregory IV, 827–44).

962: Otto I crowned Emperor.

1002: Death of Otto III.

Eleventh century: San Vincenzo in Galliano and San Pietro in Civate. Abbot Desiderius at Montecassino (1058–85); Byzantine colonization of art in southern Italy.

End of eleventh – beginning of twelfth century: Frescoes depicting scenes from the life of Saint Clement in Rome.

1128: Mosaic in the apse of San Clemente.

EAST

491–518: Anastasius: consular diptychs.

518–27: Justin I.

527–65: Justinian: Justinian classical revival.

532: Nika riots. Burning of Santa Sophia. Reconstruction of Santa Sophia and Holy Apostles. SS Sergio e Bacco.

610–41: Heraclius emperor; silver plates with story of David.

632: Death of Mahomet.

635–61: Conquest of the Arabs in East.

717–40: Leo III Isaurian Emperor; start of iconoclastic struggle.

842: Death of Theophilus, last iconoclast Emperor.

867: Start of Macedonian dynasty. Macedonian classicism.

BIBLIOGRAPHY

J. BECKWITH, *Coptic Sculpture 300–1300*, London and New York *1963*

J. BECKWITH, *Early Christian and Byzantine Art*, London and New York *1970*

O. DEMUS, *Byzantine Mosaic Decoration*, Boston

V. W. EGBERT, *Mediaeval Artists at Work*, Princeton *1967*

A. GRABAR, *Byzantine Painting*, New York *1953*

A. GRABAR, *Early Christian Art*, New York

J. P. NATANSON, *Early Christian Ivories*, London and New York *1953*

E. PANOFSKY, *Renaissance and Renascenes in Western Art*, Stockholm *1960*

S. RUNCIMAN, *Byzantine Civilization*, London and New York *1933*

S. RUNCIMAN, *Byzantine Frescoes from Yugoslav Churches*, London and New York

C. SCHUG-WILLE, *Art of Byzantium*, New York *1970*

D. TALBOT RICE, *Art of Byzantium*, London *1959*

D. TALBOT RICE, *Byzantine Art, New York 1963*

LIST OF ILLUSTRATIONS

155

156